THE CROCODILE RIVER

A memoir by
Pauline Magosvongwe

First published in Great Britain in 2022 by:

Carnelian Heart Publishing Ltd

Suite A

82 James Carter Road

Mildenhall

Suffolk

IP28 7DE

UK

www.carnelianheartpublishing.co.uk

©Pauline Magosvongwe 2022

Paperback ISBN: 978-1-914287-36-7

Ebook ISBN: 978-1-914287-37-4

A CIP catalogue record for this book is available from the British Library.

This work is a memoir and depicts actual events in the life of the author as truthfully as recollection permits.

Editors:
Lazarus Panashe Nyagwambo & Samantha Rumbidzai Vazhure

Cover design:
Artwork - Ganime Donmez
Layout - Rebecca Covers

Book Interior:
Typeset by Carnelian Heart Publishing Ltd
Layout and formatting by DanTs Media

FOREWORD

Thank you for reading my story. Before you dive in, I want you to know my reasons for writing this book. The first and foremost is to highlight my parents' greatness. My father was an honest, hardworking, kind and generous man. His survival skills were unbelievable. Had it not been so, we would have fared much worse than we did. My mother had the same qualities. She played her part in our upbringing well, a vital role, particularly in my early education. She shaped my life.

The second reason is to relate the hardships I endured in my early life. My hope is that it will inspire young people who are encountering bumps in their life journey. It does not matter how hard things are for you today, how hopeless your situation may look – God has a way of turning things around for the better if you keep your faith.

The third reason is to appreciate all the people who were good to me during the early years of my life. Some of them were complete strangers.

The other thing which inspired me to write this book is to equip my grandchildren, nieces and nephews with knowledge of our family history.

To my siblings, I thank you all for loving me. If, in my story, it appears that I wrote more about one sibling than the others, it is due to the mind's selective recollection. We all remember some things and tend to forget others. I love every one of you equally. To my children and their families, your love for me is priceless.

Lastly, to all those I fail to mention in this book, relatives, friends and acquaintances, it is not that you are insignificant, it was just impossible to include everyone.

CHAPTER ONE

I remember my life back to the time when my father was working at a place called Umniati Power Station, the main power station that supplied the Midlands Province of Zimbabwe, which was situated between Que Que and Gatooma. The year was 1954 and I was seven years old. To my young eyes, the place was an amazing sight.

Once, there was a loud blast and we saw an inferno raging in the station, a massive fire and thick smoke rising from the cones. Nobody knew what caused it. Thankfully, my father was not on duty that day. However, after that incident, I often had nightmares.

Ours was a one-bedroomed house, part of a larger compound, and seven of us lived there. My parents, myself and my brothers Alick, Paul and Mike as well as my sister Maggie. I slept in the dining room and my brothers slept on the floor in my parents' bedroom. Maggie was still a baby, so she shared the bed with my parents. The bathrooms were communal, rows of pit latrines with partitions between each one that were often messy.

No white people were present in our compound. The few white people in the area lived in their own posh neighbourhood. Their houses were fancy compared to our humble dwellings. There were only three shops, one in the east, called John Walker, one in the west, called Charlie's and the other one, whose name I don't remember, was south-east. These were all quite far. It was just as well because most people only went to the shops once a month, soon after they got paid. All of us in the compound were paid low wages and

most used it up on that one visit. The distance was also a deciding factor. Not a single person owned a car in the whole compound. Walking was the norm of the day.

My first year of school was memorable. It was fun and games most of the time. The school consisted of one classroom which was reserved for sub-B students. On Friday and Saturday evenings, the same building served as a community centre where people gathered for recreation. There was music then and some people danced the jive or freestyled while others crowded in to watch. Occasionally, we had a live concert. Groups of people sang while others performed plays. It was entertaining and we looked forward to these events.

Since there was only one classroom, sub-A pupils took lessons outside. We learnt to write in the dust using our forefingers. The following year, I graduated to the classroom, but still there were no books. We were each handed a small black slate and a piece of chalk for writing.

One day, at break time, while playing and running around, a boy named Soza kicked me in the chest. I dropped to the ground and was out cold.

As I lay there, I drifted into a dream of me floating over my still form. The floating me was like a small, round cloud. In the dream I saw an older girl I didn't know lift me up and carry me home. I floated right above her. When she arrived, Mom asked, "What happened?"

The girl told her what had happened and my mother started crying.

"Where shall I put her?" the girl asked.

Mom grabbed some blankets from the bedroom. She

spread one on the floor, then used the other one to cover me up. Curious neighbours started pouring in.

After a while, I became restless and floated outside. Then I floated upwards until I was cocooned by clouds. In front of me, some distance away, I saw something like the sun, but it was obscured by the clouds. I glided in its direction. I felt the cool breeze fanning me. It felt so serene and peaceful.

Suddenly I was gliding back, away from what looked like the sun, back to our house. I landed near my body and just then, I regained my consciousness. My first feeling was of acute disappointment. My dream had felt so good that I didn't want it to end.

Mom hugged me and asked, "What happened? What did you see?"

"I was asleep," I answered, bewildered. "And I saw nothing." I didn't think my dream was worth mentioning.

Mom said, "You were dead for two whole hours!"

I was surprised it had been that long because the dream had felt much shorter. After a few days of recuperation, I went back to school.

In 1956 I was in standard one. For the classroom, we used a lone building near the bridge spanning the Umniati River. It was far from the other school building. The three classes made up the whole school. We were finally introduced to books. That first day, the teacher picked out two of them and read to us. I still remember one was The Tempest and the other was Sinbad of Bagdad. I was totally fascinated.

Before I go on with my story, let me give an elaborate picture of my siblings. I am the first child. My brother Alick is the second born. Usually siblings who are closer in age

quarrel or fight. Nothing of that sort happened between Alick and me when we were growing up. For some reason, my parents thought that it wasn't normal.

One day, when Alick and I had some minor disagreement, (I don't even remember what it was about) my parents seized the opportunity to have some entertainment at our expense. I was about twelve and Alick was eight. Dad cut two small branches from a nearby tree. He stripped off the leaves, then handed us a branch each. "I want you two to wallop each other. That will teach you never to pick a fight with each other!"

Mom and Dad sat down in the shade, with smug smiles on their faces, anticipating the comic scene which was about to unfold. Alick and I stood there, facing each other, armed with our branches. I was quaking in fear. Although I was four years older than my brother, he was physically bigger than me.

"What are you two waiting for?" Mom called from the shed.

My brother, being the gentle person he was, and still is, looked at me and said, "I am not doing this." He put his branch down and walked away. You will never know how relieved I was.

Aged seventeen, Alick went to work at RISCO and our quality of life improved. His financial contribution made all the difference. As the years went by, he developed an eloquent flair of speech. He certainly has a way with words. It got to the point that, in our circle of friends, whenever anyone had an engagement party or wedding, my brother was inevitably the designated master of ceremony. That's not

all. He is a good storyteller too. He tells a story or relates events in such a way that you feel as if you are watching a movie. He has the ability to paint vivid pictures in the listener's mind. He truly is gifted.

My brother Paul is the third born. He and I are alike in many ways. We are both demure. We both avoid confrontations or arguments. We both can express ourselves better on paper rather than vocally. We both like to read and travel. What I like most about Paul is he is so agreeable. When we were growing up, I felt that I could confide in him about anything without the fear of him ever criticising or judging me.

One of my friends nicknamed him 'agreeable'. I don't know if he was aware of that nickname. When he started working, he took over the family's financial responsibility from Dad, who had retired, and Alick, who had lost his job due to an accident. He did a good job of it over the years.

The fourth child in the family is Mike. He is a talented, left-handed guitarist. He played with several bands in the country, including the then famous Black Eagles. Mike is a highly intelligent person, and I have no doubt he would have sailed through college if he had been given the chance. Unfortunately, like in my case, Dad did not have the money. He is on the quiet side and he is even-tempered.

Maggie is the fifth. She is the most determined person I've ever known. The word 'impossible' is not in her vocabulary. She can tackle any difficult task or situation and make it look like nothing at all. She inevitably dropped out of school in sixth grade because of our financial issues, but it didn't curb her ambition to succeed in life. In 1981, my sister went to

work for the Catholic priests at Chireya mission.

The conditions there were rather primitive at the time. My sister had to use a cast iron wood stove to cook the priests' meals. The water had to be fetched from outside. She also had to carry the prepared meals to the main house which was a distance from the kitchen. Normally it would require a couple of trips to deliver the prepared meal, dishes and all. But Maggie had a solution for that.

She always piled everything in a huge wooden tray, placed it on her head, and grabbed a jar of milk in one hand and a loaf of bread in another. She would then confidently walk to the dining room where the priests waited for their meal. I would watch the precariously balanced tray on her head, fearful that it might tip over and come crashing down. Not once did it happen.

After working for the priests for over a year, my sister decided to do something to improve her life. First, she became a nun in the Light of Life Christian Group. She then started studying to write GCSEs externally. She passed and went to a teacher's college. Three years later, she had a high school teaching degree, and immediately started her teaching job. She didn't stop there, she continued studying and is now a lecturer at a local college.

My brother Mark came next. He was the kindest person I have ever known. He was loving and had a soft, caring way. Mark was such an easy person to love. He loved everyone around him regardless of their status. Like Alick, Mark was a storyteller. The difference was that, while Alick leans on the dramatic side, Mark tended to be humorous. Even if he told the same story more than once, I still found myself laughing

my head off. I remember whenever I felt low or depressed, I paid him a visit and I always had a good laugh. Sadly, he passed away when he was only fifty.

Chris is the youngest. He is such an easy person to get along with. He is the adventurous one, considering his brave venture to Namibia. He is also very courageous. When he returned from Namibia after a five-year stint, he started a business in cabinet-making. Frankly, at the time I thought it was a risky thing to do and I feared that he would lose the lump sum he invested into the business.

In the beginning, it looked like it was going to fail. But his faith, patience and hard work paid off. He is now well established, and he took over the family's financial responsibility from Paul, after he retired. Although Chris is not an avid storyteller, he is definitely a good listener. I always loved telling him about my adventures in the various places I had worked. He absorbed the stories, hanging onto every word.

Sometimes he repeated after me in a dramatic way and usually the stories took a humorous turn even if they were not originally funny. That is the way I see my siblings. I admire them all.

CHAPTER TWO

My father had four siblings, two brothers and two sisters. He hadn't seen them in a very long time and missed them very much, often talking about them longingly. After we had been in Umniati for a few years, his younger brother, Uncle Conrad, paid us a visit. That was in 1952. Dad was overjoyed. It was funny watching them vigorously shaking hands for several minutes. They stayed up half the night talking animatedly. My uncle was a jovial person and they both laughed a lot.

In 1956, my father's sister, Aunt Serbia, visited us. My father was elated to see her. My siblings and I had never met her before. She was a teacher and not many women had jobs during this period. I admired her and vowed that I would become a teacher when I grew up.

When it was time for Aunt Serbia to leave, I asked Mom if I could go with her. Mom refused because she needed me to take care of my siblings whilst she ran errands. Instead, she offered my brother Alick the opportunity to go with our aunt. I was so angry with her.

Dad always came home at 5 p.m. He then did some carpentry or some gardening. He never liked being idle. On Sundays, he went to play soccer. I remember watching some of his matches. He also used to read, a skill he had had to learn by himself since he never went to school.

One day, a man we didn't know came and knocked at our door. Mom went to answer.

"Good morning," the man said gravely.

"Good morning." Mom was instantly anxious. She had sensed that something was wrong.

"I am afraid there has been an accident," the man said sympathetically. "Your husband slipped and fell from the tower." Seeing my mom's crumbling face, the man quickly reassured her, "Don't be alarmed, your husband is alive. Fortunately, his fall was broken by a bar."

Just then, a car pulled up and some men carried Dad into the house.

Mom broke down and cried but Dad comforted her. "We should thank God that I didn't fall all the way down. If that had happened, I could have died." Later, a doctor came and examined Dad. He had some broken ribs and it took a while for him to recuperate. After he recovered, he resigned from his job and we moved to a nearby town called Que Que. He put us all on the train and followed on his bicycle. This was in 1957.

I was eleven years old. Alick was seven, Paul was five, Mike was three and my sister Maggie was just a year old.

Dad took the first job he could find at Globe and Phoenix Mine because we urgently needed food and a place to stay. It turned out that this job was worse than the previous one. He had to go underground to do some mining. It was so dangerous that each day he left for work, we didn't know if he would come back.

We shared one mud hut, the seven of us. I was enrolled at the local Globe and Phoenix school. I was in standard two. There was barely enough money for food and clothes, let alone my education. My parents bought second-hand books from neighbours, then managed to scrape up enough money

for my fees and uniform. Some distant relatives also chipped in to help.

When I showed up to my class, I was surprised to see that I was the youngest kid. My classmates were all bigger than me and I felt intimidated. Luckily the teacher, Mr Bob, took me under his wing. I was given special treatment and never got any form of punishment, while the rest of the class sometimes got some caning for failing to hand in their homework. Dad's salary was much less than before and he got it after five long weeks. We had only one meal per day, in the evenings.

Being the resourceful man he was, my father made a wooden bookcase for me to carry my books and other school stuff. One day, after school, I decided to join other kids who had gone into the bushes to look for wild fruit. I drifted from one bush to another, enjoying the fruit, and lost my bookcase in the process.

When Mom saw me arrive empty handed she asked, "Where is your bookcase?"

"I...I..." I stammered, immediately panicking. "I forgot it somewhere in the bush where I was eating fruit." I knew I was in real trouble.

"Retrace your steps this minute!" My mother screeched. She was livid. Although I scoured the whole area right up to the school yard, there was no sign of the bookcase.

Later when my father came back from work and was told about the matter, he said, "That has sealed your fate. You have just let your chance for an education slip through your fingers."

I was to stay at home and forget about school. This was

hard for me to accept because I knew without an education, I would end up leading the same life of poverty as my parents.

The next morning, I went to school without any books. My eyes were red from crying. I explained what had happened to my teacher. Being the kind man he was, he took pity on me. "Don't worry about it," he assured me. He asked my classmates to share their reading books with me. Each pupil was asked to contribute a sheet of writing paper. We were a class of forty- five, so I had heaps of writing paper at my disposal.

Six months after my father started working in the mine, there was a terrible accident. Dad went down the mineshaft with two other guys and got trapped by huge rocks after a blast. Although they were later rescued, it shook my dad to the core. The stress of working in such difficult and dangerous conditions was starting to take its toll. Mom finally persuaded him to resign. We were kicked out of our company accommodation soon after that.

Since we had nowhere to go, Dad took us to the train station. It had two waiting rooms, one for first and second class travellers and another one for third and fourth. The former was off limits, but the latter was free for all and some people, especially from Mozambique and Malawi who found themselves homeless or in between jobs, would stay there.

"You guys have to stay here while I look around for a job," Dad told us. He took off on his bicycle which we called "the green humber" because of its rare green colour.

The train station was right in town. It was situated on one side of the main street and on the other side there was a row

of stores, restaurants and fish-and-chips shops. In later years this train station was relocated further away from town to allow for the town's expansion.

Dad would come back in the evening, tired after his job hunting. "No luck today," he would say sadly. "But I hope to get something soon, everybody cheer up." That last part was added for Mom's benefit. As far as the rest of us were concerned, we were having an adventure.

The waiting room was a large hall like building. One side was left completely open. We chose a corner, spread our blankets and huddled for the night. People came and went at all hours. Two trains arrived in the middle of the night every day. There was one from Salisbury to Bulawayo that arrived at midnight, and another from Bulawayo to Salisbury that arrived at 2 a.m. You can imagine the racket! Whilst a large group of people noisily left the waiting room to go and board the trains, another disembarked came in. We children slept through it all! But I imagine it must have been hard for my parents.

In the mornings my mother, along with other homeless people, made open fires outside the building for cooking. Mom then sent me across the street to buy some bread. After eating, we kids ran around playing happily.

One day Dad came back with some good news to share. "I found a job and I am starting tomorrow!" He had secured the job at a company called RISCO (Rhodesian Iron Steelworks Company). It was about ten miles from Que Que.

The only snag was that the company had a backlog on employees' accommodation. Dad was told that he would be

allocated a place to stay after a month's wait. On his way back from RISCO, my father stopped at a place called Gaika where he talked to a woman we knew from Umniati. The woman agreed to accommodate us temporarily. We trooped into the hut that she set aside for us, a pole and mud one that was dark and musty inside.

The days dragged by until Dad finally told us our place was ready, "Everybody pack up your things." We went into a frenzy, glad to say goodbye to the dark dank hut!

The compound was situated where the present suburb of Rutendo stands today. Our new home was one large, bare room. It had a concrete floor and asbestos roofing. We piled our bedding and clothing in one corner and food and utensils in another. We had to make an open fire outside to cook our food. As usual, the bathrooms were communal. That night, when we went to sleep, the concrete floor was ice cold. It was in the middle of winter.

The following day after work, Dad found an old metal bucket. He drilled big holes around the bucket then filled it with chunks of wood. He lit a fire, and when the wood had burnt down, he brought it inside. The red-hot embers were effective and the whole room felt warm.

In the middle of the night, Dad woke up. He felt so weak that he could hardly move. With superhuman effort, he crawled to the door and opened it. He then went back and tried to wake Mom up, but she was so drowsy that he had to drag her out. Dad then carried us kids outside one by one. We were all too drowsy to walk. It was only later when we heard a whole family had perished because of that method of heating, that we realised carbon monoxide was the cause.

One day, my brother Alick wandered onto a nearby golf course. As he stood there, watching the golfers, who were all exclusively white, one of them called him over. When my brother approached him, the man handed my brother his bag of golf clubs and told him to carry it and follow him. My brother did as he was told even though the clubs were so heavy. He was only a little boy. At the end of the game, the man handed my brother a shilling.

Mom was horrified when she saw my brother's bruised shoulders. At the same time, she was grateful when he handed over the money. Straight away, she went to a nearby butcher's shop and bought some offal and we enjoyed a feast.

I had enrolled into the local school. It was a very small school with a few classrooms. The year was 1958 and I was in standard three. To my surprise, we had to share a classroom with the standard two class. That was not all. We had to share the teacher too! Our two classes were separated by an aisle. The teacher gave one class written work, whilst the other did silent reading. Sometimes he sent one class outside to read aloud while he gave the other class a lecture. It was very distracting, but I still managed to pass with good grades.

That same year, we had an unexpected visitor. We were all delighted to see Dad's sister, Aunt Miriam arrive. She looked so much like Dad and she had the same easy cheerful character. Dad was always excited when one of his siblings paid us a visit. It was the first time we met her. I sometimes sat by her side and said, "Aunt Miriam, can you please tell us some stories?" She complied and quickly had us all smiling.

One day, she startled us by announcing, "Tomorrow I am

going back home."

"Oh no, you are not! Please stay a little longer," I pleaded.

"I wish I could stay, but I really have to go," she responded in her soft manner. "I promise you that I will come back to visit next year."

Unfortunately, she passed away before she got the chance to visit again. Later, I gathered that my aunt had intended to stay longer when she first arrived, but our living conditions were not favourable. It must have been very uncomfortable for her to share the same sleeping space with her brother and his family.

Our diet at this point was quite poor. Dad bought a big bag of mealie meal. That was about all he could afford so we had no relish for our *sadza*. Mom went out and picked some edible weed called *mowa*. Besides her, the family was alright with it. Our aim was to fill our tummies and it didn't matter with what.

Mom, on the other hand, was so picky especially at the time when she was expecting my brother Mark. One day, when I gave her two grasshoppers I had caught, she was very grateful. She roasted them over the open fire then ate them with her sadza. My brother Alick said, "Sis, let's go out tomorrow and try to catch more grasshoppers for Mom," and I readily agreed.

The following morning, we walked to the foot of a nearby mountain. It was still early so it was shadowy. We gathered several grasshoppers. They are incapable of moving in the early morning hours because of the cold. They only start hopping around when the sun rises. When we gave Mom our catch, she was so happy and my brother and I felt good.

RISCO had started a project where it built houses for its black employees at a place called Torwood. Soon, everyone was transferred from the old compound to Torwood Township. This time we got a four-room house, but the rooms were all bare. Dad wasted no time. He got down to work and made a table and four chairs. Then he made a bed for their bedroom and one for me. The boys slept on the floor in the dining room. There was no electricity or running water in the new houses though. The houses were built in groups. Each group was allocated an alphabet letter and shared the bathrooms which were built in the middle of the houses. We lived in the D section of Torwood. The bathroom issue was a headache. Most of the times when I went for a shower, I found a long line of women waiting their turn. Some people were so inconsiderate and took their sweet time. It was very frustrating.

Dad's salary was about £4 per month. A 200-pound bag of mealie meal was £2. That meant he had to perform miracles with the remaining £2 so that it stretched to cover all our basic needs for the month. I am proud to say Dad rose to the occasion. We would have been worse off if it weren't for his resourcefulness.

In 1959 I was entering standard four. Unfortunately, Torwood School had only up to standard three. I went back to Globe and Phoenix school where I stayed with my parents' acquaintances.

However, my stay wasn't a pleasant one at all. This couple was at each other's throats most of the time. The atmosphere in this home was so thick with antagonism you could cut it with a knife. Food was also scarce, even though Dad

contributed to my stay. After a month, when Dad came to visit me, I told him that I didn't want to stay with the people any longer. I went back to Torwood while Mom and Dad thought of what to do with me.

Finally, Dad said, "I've thought of something. Pauline could use my bicycle to commute to school." Mom was sceptical of this idea. I shared her pessimism because the distance between Torwood and Globe and Phoenix was quite long and daunting for a little thirteen year old girl. But I agreed to give it a try.

I set out at six in the morning that Monday. I was too short to sit on the saddle so I just paddled without sitting and when I got tired, I got down and pushed the bicycle. I decided to take a short cut that was known as '7 miles.' It was a dusty, lonely stretch of a road with thick woods on either side. When I finally arrived at school, late and covered in dust, the teacher and the rest of the class were amazed that I had cycled from Torwood.

I enjoyed my lessons very much. My teacher was a very patient and kind man who always taught with a smile on his face. His name was Mr. Mangowe. Besides our five regular subjects, English, Math, History, Geography and Shona, we had supplementary books to read in our own time. I liked that best. In no time I had gone through an endless list. The likes of Oliver Twist, David Copperfield, Ivan Hoe, Jane Eyre, King Solomon's Mines, Treasure Island, Lorna Doone, Adventures of Tom Sawyer, The Coral Island and many more.

On that first day of my commute, I arrived back home to find my mother sitting outside, looking worried. "How did

it go?"

"It wasn't so bad," I assured her. But the truth was, I didn't know how I'd done it. I believed God must have pedalled that bicycle for me.

The kind of job my father did was tough. He worked in the blacksmith shop. He was exposed to intense heat. All day long, Dad and his workmates threw iron into the furnace, and then while it was still red-hot, they moulded it into the required shapes using hammers and other tools. Things were still primitive back then. The job was taxing but Dad stuck it out.

To make matters worse, Dad's immediate boss, a young white man, gave him a hard time. He was always demeaning towards him and sometimes called him stupid. Still, Dad hung on to his job for dear life. Things came to a head one day when Dad's young boss went as far as slapping him in the face. Not only did he hurt Dad physically, but he also crushed his spirit.

That day, Dad came back home from work looking grim and called Mom into their bedroom. I didn't hear their conversation, but Mom told me about it later. He wanted to resign the very next day and he asked her to start packing after he explained what had happened. He could no longer stick around and risk being goaded into retaliation by his boss and possibly end up in jail. Mom managed to speak some sense into him by reminding him that we would have nowhere to go. He needed to endure for our sake.

Mom, being who she was, decided to pray about it instead, "Lord, thank you for the children you gave us. Your love knows no bounds. May you kindly give my husband the

strength he requires to endure the injustice he faces at work. We all depend on your compassion. Amen." She then advised him that the next time he was insulted, he should pretend it was a compliment so his boss wouldn't have the satisfaction of knowing that his words hurt Dad.

That advice seemed to work, because the young man left him alone and found someone else to torment.

MY BROTHER PAUL, IN HIS OWN WORDS

Our upbringing was normal, with two loving parents. Though it was low class, I should like to think that my happiest days were when I was growing up. Our main diet was *sadza* and relish. The relish ranged from *muriwo* to dried beans and fish.

Dad had a way of making unpopular food look and taste good. For example, poor people like us who could not afford real breakfast like tea and bread had to eat mealie meal porridge. No one liked it, especially my siblings and me. So, Dad would first sour the mealie meal by soaking it for a couple of days. When he finally made the porridge, it tasted really good. We couldn't have enough of it.

We could not afford any form of snacks to take in between meals. Dad had an answer for that. Instead of throwing away leftover *sadza*, he would mesh it up in water, and then ferment it with a sorghum grain. This was left overnight. The following day this mixture made a very tasty and filling beverage called *maheu*. It was delicious and we loved it.

I vividly remember my life in Torwood, a high-density suburb. Most people knew each other as we lived in semi-detached houses. While in primary school, (elementary and

middle school combined) I enjoyed my sleep very much although we slept on the floor. Consequently, I was always nearly late for school, resulting in running daily to avoid punishment which was invariably corporal. At times, when I knew I wouldn't make it on time, I would pass through the clinic and fake an illness, which would serve as a passable excuse for my tardiness.

When I look back, I see God's love. One of the reasons I say so is that many families shared the bathrooms which were cleaned every morning. The best time to visit these facilities was just after they were cleaned. Soon after, they would be a mess. We had no shoes and went in there barefoot, but we rarely got sick. That amazes me a lot when I think about it now.

Despite Dad's meagre salary, we never ever went to bed hungry. Dad was so creative that he could conjure up a meal from almost nothing. Most people we knew had one measly meal per day. But because of Dad's hard work and resourcefulness, we were fed.

In 1966 tragedy rocked the family. My brothers Alick, Mike and I were struck by typhoid. We were hospitalised and later transferred to Gwelo's Infectious Diseases Isolation hospital. It was devastating for our parents. Rumours were rampant that typhoid was a killer disease and many who got it didn't survive.

While other patients had hoards of visitors, bringing with them goodies, we had none. Dad couldn't afford the bus fare from Torwood to Gwelo. One day, Dad sacrificed to cycle the 70 kilometres to see us. We were overjoyed to see him, and he was pleased to see us feeling better. I liked the

hospitalisation for several reasons, namely:

1) The diet was better than the one at home,
2) I slept in bed sheets,
3) There were no household chores,
4) I got lots of sympathy,
5) Dad visited us once every two weeks.

Looking back now, I realise it was a tremendous effort on his part to make those gruelling trips.

There was nothing our Dad couldn't do.

Building: He did some paving around our living quarters, built chicken runs for other people for a fee, and later when he retired, he built houses at our new home in Gokwe.

Mechanic: Dad fixed his own bicycle and almost any household item that needed repair.

Fishing: He teamed up with a friend and they would go to catch fish using nets. Often, they would do all-night stints and come back in time to go to work. This improved our diet considerably.

Gardening: He grew orchards wherever we stayed and vegetable gardening was his specialty.

Helping: He gathered firewood, fetched water from the borehole, more than two kilometres away and helped with the cooking whenever necessary. All these chores are considered feminine in our culture, but he did them and made life much easier for Mom. These are a few of the memories I have of my father.

CHAPTER THREE

In my eyes, Dad was a hero, a superman and a saint all rolled into one. The reason I say so is that he endured so much just to ensure our comfort. He was resilient and could overcome impossible situations that confronted him.

He was also extremely kind. He was always helping neighbours. Once, Dad took in a couple of kids whose father had lost his job, although he himself was struggling to keep his head above water. The amazing thing is how he could have such fine qualities when he himself grew up in a very harsh environment.

In the year 1912, before Dad and his siblings were born, his father wandered into the neighbouring country of Mozambique. As he travelled along a remote part of that country, he stumbled upon a starving family. My grandfather struck a deal with them. He would send them grain as soon as he got to his home and in exchange he would take some cattle or goats. The people had no animals, but in their desperation, they offered to give my grandfather a girl to take home as his wife. This was a common practice in both countries during the time. My grandfather accepted the offer.

They selected a girl, without her knowledge, and sent her to the well to fetch some water. When the girl arrived, my grandfather was waiting for her as arranged. He grabbed her and travelled back to his home.

At first, the girl nursed the hope that she might be able to escape. But as they travelled across forests and rivers, up and down mountains, that hope died. She knew that even if she managed to escape, she couldn't possibly find her way back,

not to mention the danger of wild animals.

My grandfather was already married at that point and the abducted girl was to be his second wife. He kept his side of the bargain and sent the grain. Later, the girl bore him five children. The first was a boy who she named Paul. The second was a girl and she named her Miriam. The third born was my father who she named Krispen. The fourth and fifth were a girl and a boy and their names were Serbia and Conrad respectively.

As my father grew up, he became aware of the fact that his mother was being abused by his father. She often got beatings while he watched. That hurt him deeply but as a little boy, there was nothing he could do. When my father was about twelve, his mother said to him, "I want you to get out of this place. Go and find yourself a job as far away as you can. Don't worry about me, I'll be alright."

She didn't want him to continue witnessing the brutal beatings she got. She was afraid that Dad might eventually try to defend her and end up getting the beatings himself. My father wasn't happy about this decision. "But Mom, I can't leave you here," he protested.

In the end, my grandmother managed to persuade my father to leave. My father and his mother furtively prepared for his departure. The following morning Dad pretended to be going to his usual chore of cultivating the fields.

My grandmother pretended she was going to the river to fetch some water.

When she got to the river, Dad got out of his hiding place. Together they walked for some distance. Then Dad's mom said to him, "Whatever happens, remember that I love you

very much."

"I love you too mom. I promise I will be back to get you out of this place."

Unfortunately, that was the last time he saw his mom. My grandmother stood there, her heart breaking, as she watched my dad walk away.

My father walked the entire day. He stopped once to eat some of the food his mother had provided for the journey. When the sun got low, he sat down to rest and eat. When nightfall came, he climbed up a tree and tied himself to a branch so that he wouldn't fall while he slept. He did not sleep on the ground for fear of wild animals. The next day, at dawn, he was on his way. He went through the same routine for several days. When his food was gone, he ate wild fruit as he went.

After what felt like forever, he finally reached the town of Umtali. He managed to get a job as a house boy. That's what male domestic workers were called in those days. If you were a female, you were called a house girl. It was always 'boy' or 'girl' regardless of your age.

Every employer's house had an out room some distance away which accommodated the male domestic workers, called the boys' *kaya*. The female workers would all return to their residences after work. After his first day, my father went to his boy's *kaya*. He didn't know how to cook *sadza*

The opportunity had never arisen for him to learn how. There he was, hungry, without the slightest clue how to fix it. He thought of giving it a try anyway. He filled a pot with water and sat it on the fire. When the water heated, he added mealie meal and stirred just like he'd seen his mother do. It

turned out disastrous and inedible. He went to bed hungry. The next day he helped himself to his employers' food and was almost caught doing so, which would have cost him his job. Later, he met some fellows from neighbouring houses, and they taught him how to cook *sadza*.

Several years went by. Back home, when things got too bad for his mom to bear, she ran away. No one knows where. She never came back. Once, Dad took time off work to track her down, but there was no trace of her. A few more years went by and Dad finally accepted that he would never see his mother again.

One day after work, my dad went next door to visit his friend. He was puzzled to find him with a group of people in a heated discussion. When he entered the room, one of them was saying, "We are completely wasting our time in our present jobs. The paltry salary we are getting is a mockery!"

Another fellow cut in, "So what can we do about it?"

"Maybe we should consider going to South Africa."

"I don't know if it's a good idea, because that is a hazardous journey. Many people have perished before they could make it."

A third man interjected, "It might be worth the risk. I heard that jobs are abundant and the pay is good over there."

My dad chided in, "Count me in guys. I am for it."

Eventually, everyone in the room was sold to the idea.

After lengthy preparations and planning, the group finally set off on foot, one Sunday morning. It was the norm for people to travel to South Africa this way. Most could not afford other forms of transport.

The year was 1936, and the group consisted of six men.

They walked from dawn to dusk and then stopped to make a fire. After eating the food they had brought, they lay down around the fire for the night. The fire not only provided warmth but offered protection from wild animals.

After a considerable period, they arrived in Bulawayo. From there they decided to proceed to the South African border. Only one person in the group knew the way because that was his second trip to the south. He led the way as the group followed a well-worn path which led them deeper into the jungle.

Hours later, they came to a fork in the path. The leader of the group wasn't sure which path to take. It had been a while since he had travelled the route. Finally, they randomly picked the path to their right. An hour later, the path petered out. Rather than turn back, they decided to go on, hoping to come across their missed path further along the way. That didn't happen. Instead, the jungle closed in on them. The grass was so tall they couldn't see behind or in front of them. Suddenly, they heard some noise which sounded like a stampede. "Everybody, up in the trees!" the leader shouted.

They all climbed the nearest trees they could find. A few minutes later, a herd of zebras flew past with a lion in hot pursuit. The group stayed in the trees for a little while longer, just to make sure that the lion was gone. They then resumed their journey. Dad was convinced they would all perish in the jungle. Their food supply was long gone, and they didn't have any water. Also among their woes was that the sun was setting and they didn't relish the thought of spending the night in that hostile environment.

Suddenly one of them shouted, "Smoke!"

Dad and the others looked at where he was pointing, and sure enough, a thin pillar of smoke rose above the trees. The group cautiously walked towards it. A while later, they saw a hut. As they peered from behind the bushes, they saw a man crouching in front of the fire, roasting some meat. They threw caution to the wind and revealed themselves.

The man was welcoming, much to everyone's relief. The man told them that he was a hunter. Dad and his group explained to him that they were on their way to South Africa but had got lost. "Well, you can spend the night here and rest. I'll show you the way tomorrow morning," he offered. The group accepted gratefully.

The following morning, after supplying the group with roasted meat and water, the hunter accompanied them until they reached a wide path.

"You follow this route, and it will take you to the border," he instructed them.

They eventually came to the Limpopo River, which bordered the then Southern Rhodesia and South Africa. Here, the group faced a new challenge: how to cross the wide river. Swimming was out of question. The Limpopo was known as 'the crocodile river' because it was infested with hoards of the deadly reptile.

While they were still contemplating what to do next, two men in a boat approached them from the other side. "Anyone want a ride across the river?" one of the boatmen called out.

"We would like to, but we have no money to pay you for the service," Dad replied.

"That is not a problem. You can pay by working for our boss for a couple of days."

That sealed the deal. Dad and his mates squeezed onto the tiny boat and were soon on the other side. They were transported to a farm where they were immediately put to work, cultivating the maize field.

Things quickly turned ugly. A man on a horse, holding a whip, was galloping up and down the field and using the whip at random. Dad and his group realised they were in serious trouble.

After that torturous day, they were shown to their quarters, a small bare hut. They were rationed some beans and mealie meal. But beans take hours to cook and they were extremely tired after their gruelling day. They just cooked *sadza* and forced it down without any relish so they could have strength for the following day.

The second day in the field was just as bad as the first. They were relieved at the end of the day and were anticipating leaving that terrible place. But they were in for a shock.

When they tried to leave, the man with the whip shouted, "Where do you think you are going?" He lashed out with his whip for good measure. "You were sold to us by the people who brought you here, and you are going to serve a six-month period before you can be released."

Dad and his mates couldn't bear to think of enduring another day in that hellish place. Later that night, they dug a hole underneath the property fence, just large enough for them to crawl through. Their hut was near the fence and it had recently rained, so the ground was soft and their task was made easier. They managed to escape before daybreak.

They later found jobs on other farms. Although the farm

work was hard, they at least got paid for it. After several years of hopping from one farm to another, Dad returned home. That was around 1940.

Things were no longer the same at home for Dad now that his mother was gone. He and some guys from the neighbourhood got together and made plans to go to South Africa. The eight of them followed the same route Dad had used previously, right up to Bulawayo. There, an argument broke out about which route to take. "Let's go straight to the South African border," one group member, who was overzealous to get to their destination suggested.

But another member was more cautious. "I don't think that's a good idea, because we will have the obstacle of crossing the Limpopo River."

My dad finally cut in, "Look guys, this route straight to the border is a nonstarter. The last time I and my previous companions used it, we got into deep trouble. Our best bet is to go through Botswana. I know it will take us much longer, but it's safer." The group weighed their options and unanimously decided to take the Botswana route.

When they finally crossed into Botswana, they were so tired and hungry that they could barely walk. As they entered Francistown, the people there took pity on them. Several families each took a man into their homes. They were all made comfortable and were well fed. My father and his companions decided to make the most of the people's hospitality and take a well needed rest before proceeding.

Several months later, Dad called a meeting with his travel mates. "Guys," he said to them, "I think it's time we continue with our journey to South Africa." To his surprise, most of

the group members were reluctant to resume their journey.

"I don't see why we should endure another gruelling walk," voiced one man. "This place we are in right now is as good as South Africa."

"I am comfortable here," chipped in another man. "In fact, I found myself a girl, and I am getting married next month."

Only one other man was willing to continue with their journey. His name was Richard. The two of them set out once more. After travelling through Botswana they finally crossed into South Africa. They didn't linger in any of the small towns they passed. Their sights were set on the big cities.

At some point, as they walked, they saw some farms. Dad thought maybe if they took a job on one of the farms, it could help them save a bit of money to start out in the city, but he wasn't sure that his friend would agree. He broached the subject. "Our cash is running out and we will certainly need money to start out in the city," he said to Richard. "I was thinking that maybe we should break our journey and work for a while."

"You are right. Who knows how long it will take us to find jobs in the city?" That agreed, the two turned to the nearest farm. Both were hired on the spot.

"Your job is to collect eggs, put them in crates, and then pile the crates over there," the farm manager barked. "Your pay is seven rands per month and you will reside with other farm hands in that big barn."

At first, my father and his friend thought they had hit a stroke of luck. The job seemed easy enough. But they were

soon proved wrong. It turned out that the job was backbreaking. There was no end to the eggs lying around no matter how fast they collected them. There were at least a thousand egg-laying hens, and because of the type of feed they got, some of them laid eggs twice a day.

They worked non-stop, right through the day, no lunch break at all. At dusk, they were finally dismissed for the day. Dad and his friend were so tired, they barely managed to make their dinner. They boiled some eggs and had them with their *sadza*. Afterwards, as the two lay in the dark barn, they discussed their predicament. "Krispen, what do we do now?" Richard asked.

"Obviously we should move on," Dad responded without hesitation.

However, there was a snag to this option. When the two informed the foreman about their intention to leave, to their utter amazement, he was furious. "Look here guys, we don't play those kinds of games here!" He berated them. "We don't allow people to come and go as they please. You are committed to work here for at least six months before you can be released. And by the way, don't attempt to run away because you won't get far before you are caught. We have guards all over the place." Dad and Richard were floored! They hadn't seen this coming. The two reluctantly went back to work but secretly devised a plan to escape. That very night, my father slipped out of the barn and pretended to go to the bathroom, an outhouse some distance away.

He walked past the outhouse and hid in the bushes beyond. After a while, Richard followed suit. They signalled to each other with low whistles. Under the cover of darkness,

they made their escape. About thirty minutes later, they came to the fence that bordered the farm. It was all barbed wire and it was so closely knit that there was no way to pass through.

"I had thought of that, so I brought these," my dad said, producing a pair of pliers from his pocket.

"How and where did you get those?" Richard asked in surprise.

"Never mind how I got them. Let's just hurry and get ourselves out of this place!" In no time, they had managed to cut a hole in the fence and they squeezed through. It was pitch dark, but they forged on, determined to put as much distance as they could between themselves and the farm before daybreak.

As they trudged on, Richard suddenly gave a loud yelp.

"What is it?" my father asked, fearful because he had heard a hissing sound.

"I think I stepped on a snake."

"Did it bite you?" Dad asked, very concerned.

"I don't think so, but it did spit on me. I felt some spray on my face," Richard was audibly shaken.

"Let's find the road," Dad suggested.

They were a bit disoriented and were not sure which way the road was. After a while, they managed to find the road, but they were more confused than ever. They did not know which direction to take. If they made the wrong choice, they could walk right back to the farm.

After debating their dilemma, they finally agreed to go in the direction of the rising sun.

"Krispen, I hear a sound. Do you hear it too?" Richard

asked excitedly.

My father stopped walking and listened. "Yes, I hear it. It sounds like a vehicle coming."

"Good!" Richard exclaimed. "We will thump for a ride."

"Are you crazy?" Dad retorted. "Those could be the guards looking for us!"

When the vehicle got nearer, Dad and Richard hid in the bushes and the car passed. About twenty minutes later, the car drove back and passed again as it went in the direction of the farm. "You see? What did I tell you? They are looking for us," Dad stated.

By late afternoon, they were tired and hungry. When they saw another car coming and heading in the same direction they were going, they took the risk and thumped for a ride. Fortunately, it was not a car from the farm.

They arrived in Pretoria late at night and slept at the train station. The following morning, they set out job hunting. They went to the affluent suburbs. "That house is really big," Richard said, pointing to a house with a well-manicured lawn in front. "There might be a chance of getting a job to work there."

They entered the open gate. Suddenly, the biggest dog they had ever seen came charging at them. The dog looked so ferocious, they instinctively knew that if they turned and ran, the beast would make short work of them. So, they stood there, petrified. The dog barked furiously as it inched towards them menacingly.

Suddenly, Richard grabbed Dad and shoved him in front. Dad wrestled with Richard, trying to reverse the situation. The dog's owner was watching the whole spectacle from his

porch. When he had had enough of the free show, he called his dog off. Dad and Richard slipped back on to the street.

"How could you do that to me?" Dad confronted Richard.

"Don't act the saint!" Richard defended himself. "You also tried to shove me towards that brute!" Their quarrel got so heated that they ended up parting ways.

Dad decided to try the hotels. He got a job washing dishes in a hotel restaurant. Unfortunately for him, it was such a busy restaurant that the dishes piled up high all day long. By the end of the day, he hadn't had any break, even for lunch. He didn't see himself coming back the following day and he knew from experience that he would not be paid for his day's work. He just cut his losses and walked out without even bothering to tell his new boss. From there, Dad decided to try the next city which was Johannesburg. He was in luck and landed a housekeeping job in a big hotel.

CHAPTER FOUR

My mother was born in Inyanga, in the Eastern highlands. Her father died when she was just a little girl, and she barely remembered him. There were four children in her family; two girls and two boys. Her mother worked very hard to provide for them, but she was such a kind-hearted person that she always looked out for those who did not have enough to eat.

My mother and her siblings were often furious when their mother took their food and gave it to hungry strangers.

"But Mom," her elder daughter would cry, "our food is almost gone, what will we eat?"

"Don't worry Annie," my grandmother would reply soothingly, "God will provide."

Unfortunately, things didn't go well for them. My grandmother got ill and later passed away. The eldest daughter, Annie, was sixteen. My mother, Agnes, was fourteen. Her brother Silas was twelve and the youngest, Peter, was ten.

After the funeral, some distant relatives discussed the situation.

"We can't leave these children here alone," one man pointed out. "They are too young to fend for themselves."

The others agreed, but they didn't see a solution. "Who can afford to take them?" one woman asked.

"I have an idea," a man chipped in. "Each one of us should take one child to our homes."

That was agreed upon, so my mother and her siblings were separated.

The family that took my mother in was not kind to her at all. To them, she was just an extra mouth to feed. My mother was required to go and fetch water from the well, which was some distance away, early in the morning before she walked to school, at least eight kilometres away. She would come back from school in the evening, tired and hungry.

Her foster mother made it a point to prepare dinner before my mother arrived. She would then eat with her family, wash up the dishes and put them away. On that first day, when Mom arrived from school, ravenous, she asked her foster mother, "May I please have something to eat?"

"Yes," the woman answered harshly. She handed Mom a plate full of uncooked grain and said, "Go and grind that grain and make yourself some *sadza*."

The process required a lot of energy and would take nothing short of an hour to finally have her meal ready. Mom wept bitterly and wished that her mother was still alive. Eventually, she took the grain to the grinding stone and made her meal. That continued to be the pattern of her life during her stay with this family.

One day, a group of children, including my mother, went down to the river for a swim. As they played and splashed, one of them put down a challenge.

"We want to see who can swim underwater the longest time and distance."

My mother dived in and swam for some distance. When her lungs felt like bursting, she tried going up for air but to her shock, her head hit a hard surface.

She had swum into an underwater cave! Somehow, she turned and swam the other way and then finally shot up for

air. Up to this moment my mother fails to understand how it was possible that she didn't drown. It was an absolute miracle.

After some time, my mother thought of tracking down her siblings to see how they were doing. She set off on foot one morning and walked most of the day, eating *mutakura* she had prepared as *mbuva* to replenish her energy. She visited her brother Silas first. He had been taken in by some relatives who lived far from her own foster home. Her gift for him was a cap she had bought earlier on. She found him in the pasture, herding cattle. He looked sad and forlorn. They hugged and both cried. Finally, my mother asked, "How are you doing? Are they treating you well?"

"No, I am being treated unfairly. All the other kids go to school and I don't. I am supposed to earn my keep by herding cattle everyday, come rain or shine. I am so unhappy and I wish Mom was still here," he told her sadly. Mom comforted her brother as best she could then gave him the cap.

"Put this on, it will protect you from the sun." Reluctantly, they said their goodbyes and Mom returned to her foster home.

Mom's life with her foster family got worse. One day when she came back from school, she asked for her usual measure of grain so that she could grind it and make her meal. To her surprise, her foster mother had an outburst. "Look here young lady," she fumed, "grain does not fall from heaven like manna! You have to plant it, cultivate it and harvest it." After giving Mom more of her tongue lashing, she eventually gave her the small tin of grain. My mother had no choice but to accept the grain. She went to grind it and that

night she ate in tears.

When schools were closed for the holidays, Mom decided to go and visit her youngest brother, Peter. She started out early in the morning and walked for several hours. At about midday, she arrived at the homestead where her brother lived. As she walked between the huts, the place seemed deserted.

When she looked further to her right, she spotted her young brother sitting in the shade of a tree. She had not seen him since their mother's funeral. "Peter!" Mom called excitedly.

She fully expected her brother to run to her, but he didn't. Baffled, Mom walked over to where he was sitting.

"Aren't you happy to see me Peter?" she asked, concerned. Then she saw the reason why he wasn't moving. There was a ghastly wound on his foot. It was septic and the rest of the leg was swollen. "What happened to your foot?" Mom asked with concern.

"I got hurt when I was out herding cattle."

"Where is everybody?"

"They have gone to the fields."

Mom helped her brother clean himself up and put on clean clothes. She carried him on her back and headed for the Catholic mission hospital. There, she begged the nuns, "May you please treat my brother? And may you please keep him here until I come back for him?" She explained that they were orphans.

The nuns were touched. "Your brother is welcome to stay here for as long as he wants."

My mother left Peter at the mission hospital and went

back to her foster home where she was met with open hostility. It was obvious that her foster mother no longer wanted her there. Since she had nowhere else to go, my mother decided to develop a thick skin and let the hostility wash over her like water over a duck.

Things came to a head one day when Mom asked for grain to grind so that she could make her meal. Her foster mother just blew her top. "Whilst we were in the fields cultivating this grain, you were having a good time playing at school. For your own information, it wasn't me who killed your mother. I don't see why I should be saddled with you!"

After that hateful outburst, Mom knew she had no choice but to leave. The only place she could think of was the Catholic mission. On her way there, she passed by her brother Silas' village. Again, she found him in the pasture, herding cattle. The sun was beating down relentlessly. "Silas," Mom called. "What happened to the cap I gave you?"

Her brother explained that his foster father had taken it for himself. Mom was at a loss. *How could people be so inconsiderate?*

"I came to say goodbye to you. I am going to the mission. If I am accepted, then that is going to be my new home," Mom told her brother. They bade each other farewell and Mom, with her heart breaking, left her brother standing there dejectedly.

When she arrived at the mission, the nuns accepted her without a question. But after a few years, life at the mission became overwhelming for her. They had to work very hard for their upkeep. She approached one of the nuns. "I would like to thank you for accepting me, and taking care of me,

but I wish to inform you that I have decided to leave."

"Where do you intend to go?"

"My mother once told me that she had an uncle who lived in Rusapi and I am going to try to find him."

"We will not hold you against your will, my child," the nun said kindly, "but always remember that you are welcome here anytime you need a place to stay."

The following morning Mom set off on her journey into the unknown. After hours of walking, she came by a cluster of huts.

"Greetings to you," a man called out. "I don't seem to recognise you. Are you from this area?"

"Greetings to you too. No, I am not. I come from Inyanga and I am going to Rusapi to find my uncle."

"That's an impossible journey for a young girl like you," the man pointed out.

"I know, but I have no choice," Mom explained. She went on to tell him her story up to that point. By then, the man's wife had joined him.

"You poor child," she said sympathetically. "You have had such a rough time. Stay with us for a while," she offered.

Mom accepted the invitation gratefully.

For a while the people treated her kindly, but after about a month, the woman surprised Mom by asking, "Agnes, when do you plan to go and find your uncle?"

Mom got the message and she was on her way the following morning. She walked for several hours. By midday, it was blazing hot. She decided to rest under a shady tree.

There she was, in the middle of the jungle, all alone and feeling hopeless. She started to pray, "Lord help me on this

journey to find my uncle. Please protect me from any harm. Dear Lord, please make my life better. Amen." Immediately, she fell asleep.

She was abruptly roused from her slumber by a loud voice calling, "Agnes! Agnes!"

She rubbed her eyes and looked around for her caller, but there was no sign of anyone, which left her perplexed. The sun was just going down behind a mountain. She quickly got up and started to run. She had to find a homestead before it got too dark. It would be extremely dangerous for her to spend the night in the wilderness since there were wild animals in the area.

After about an hour of running and rapid walking, she finally saw some huts ahead. She was so relieved that she almost collapsed. When she had gathered herself, she went up and knocked on one of the huts. "Who is it?" a man asked from inside.

"You don't know me. My name is Agnes," Mom answered meekly.

The man quickly opened the door. Mom related her story, and ended by pleading, "May you please accommodate me for the night? I will be on my way as soon as it is light."

The man took Mom to his daughters' hut. "Girls, we have a guest. Can you give her something to eat before she goes to bed?" To Mom the man said, "I hope you have a restful night my child."

The next morning the whole family was kind to her. "Since you don't know for sure that you will find your uncle, why don't you stay with us?" they kindly suggested.

Mom knew better. From her previous experience she

knew that once the novelty wore off, so would the hospitality. She stayed only for three days, just long enough to rest her feet.

My mother continued her journey, asking for directions as she went. She took breaks along the way, some short and some long depending on how she was treated by her hosts. After a very long time, she arrived at her uncle's village. As she entered, she saw a tall, gaunt man working in a vegetable garden. She approached him and introduced herself. "My name is Agnes, and I am looking for my uncle, John."

The man stood there, staring at Mom for a long time. Then he finally said, "I am John. How did you get here? Where are your brothers and sister? Are you alright?"

The questions rained and Mom answered them as best as she could. Then her uncle took her to his wife. Mom was welcomed into their home.

For the first time since her mom's death, she felt secure and loved. She lived with her uncle and his wife up to the time she got married to my father.

Back in Inyanga, my mother's sister, Annie, did not fare well either. In fact, of the four of them, she got the worst deal. The couple that took her in fought over the issue.

"I don't want her here. I have a large family of my own!" Aunt Annie's potential foster mother declared vehemently.

Her husband tried to placate her. "She won't live with us for long, and besides, she will help you with housework."

The woman wouldn't hear of it. She gave an ultimatum. "Either this girl goes, or I am out of here!"

After giving it thought, Aunt Annie's foster father devised a plan to get rid of her. He approached a rich man who lived nearby. Anyone who owned at least twenty cattle and had lots of grain was considered rich at the time.

"I'd like to talk to you," the foster father said to the rich man.

"About what?"

"Well, the thing is, I was wondering if you would like to take a fifth wife. I have a very pretty girl at my home. You can come and see her for yourself."

It was a common custom at the time for rich men to accumulate as many wives as they wished. The man jumped at the opportunity as he found my aunt beautiful. She was about sixteen years of age at that point. When the man came over and saw my aunt, he made big offers. "How about I give you five cattle, ten goats and five bags of grain?"

My aunt's foster parents were more than happy with the offer. They had killed two birds with one stone! That very week, some men came to get my aunt. The rich man had sent them. Aunt Annie cried and fought the men bravely, but she was no match for them. Reluctantly, she started her married life.

Things got worse from there. The other four wives treated Aunt Annie with hostility. They were jealous of her youth and beauty. They overworked her out of spite. One day when things got really bad, my aunt took a long walk into the woods. There, she cried until her eyes were red and swollen. Afterwards, she knelt and prayed, "Please Lord, get me out of this unbearable situation. I know you are the God of love. Amen." She then walked back feeling a little bit better.

Her prayers were answered sooner than she expected. The following day she went to the river to do laundry. She found three other girls already there. They were immersed in a serious discussion. It turned out that all three girls were in the same situation as hers.

One girl was saying, "My husband's other wives ganged up on me and beat me up."

A second one said, "For me, it's my husband who beats me up. His wives seem to sympathise with me."

Aunt Annie then told them about her own situation, "I work like a slave. I fetch firewood and even do laundry for the whole family. I am so exhausted and miserable."

"Let's do something about this. God helps those who help themselves."

"What do you propose we do?"

"We should run away."

"Where would we run to?"

"That wouldn't be a problem," chipped in the third girl who had been quiet all along. "I have an uncle who works in Penhalonga. He will no doubt welcome and accommodate us until we find jobs."

Aunt Annie liked the idea, "I think we should go for it girls. This is our only chance for freedom."

After their discussion, the four girls unanimously agreed to escape.

They made plans and set the time and date for their rendezvous.

When the day came for their departure, my aunt was the first to arrive at the agreed spot. It was dawn and still a little dark. She had managed to slip out of the hut, pretending to

be going to fetch some firewood as per her daily routine. She stood there nervously, waiting for the other girls to arrive.

Suddenly she heard some movement in the brush. Her heart skipped a beat. She thought it might be a wild animal or her husband coming after her. To her, both possibilities were terrifying. She breathed a sigh of relief when one of the girls emerged. Soon after that, the other two joined them. They were all so glad that their plan was under way that they danced until the grass disappeared from under their feet.

After they exhausted their excitement, the four girls commenced their long journey to Penhalonga. Each evening, they stopped at the nearest homestead and asked to sleep for the night. They were welcomed with food and water and given safe refuge. A few days later, when they finally reached their destination, they located the other girl's uncle easily. "Uncle Ben, these are my friends," she introduced. "We all ran away because of the harsh situations we were in. Do you think you can find jobs for us?"

"I don't think so," the uncle answered. "This is a very small place and jobs here are just non-existent. However, I have a friend who works in Umtali. I am sure he can secure jobs for you all."

That very Friday, Uncle Ben's friend came over. Aunt Annie and her friends were sitting in the small dining room after their dinner. They were chatting happily when they heard a knock at the door. "Come in, it's open!" one of the girls called out.

In came a very handsome young man. He was tall and very light in complexion. All four sets of eyes stared at the young man. "My name is James," the young man introduced

himself. "Is Ben here by any chance?"

One of the girls answered, "He has just stepped out, but he should be back any time soon. Please have a seat."

As James sat down, his eyes were drawn to Aunt Annie. Aunt Annie was also struck by his good looks. But since it was tradition for girls not to show open interest in the opposite sex, my aunt glued her eyes to the floor. James continued to chat with the other three girls until Ben came back.

"I didn't expect you until much later, but still I am glad to see you pal," Ben greeted his friend jovially.

"Well, I got off work early because my employers went to Bridal Veil Falls for the weekend. I hear these young ladies are looking for jobs?"

"You heard right. Do you think you can help on the matter?"

"I could try, but they have to come with me to Umtali."

The next day, James and the four girls travelled to Umtali. He let the girls stay in his boy's *kaya* while he camped with his friend next door. As the days went by, one by one, the girls found jobs in the surrounding houses, with James's help. The only one left without a job was Aunt Annie. When she confronted James about it, he confessed, "I don't want you to get a job. I fell in love with you the moment I saw you. I want to marry you." My aunt was secretly happy to hear this declaration, but outwardly, she acted uninterested.

One day, Aunt Annie was sunning herself behind the boy's *kaya*. She was so lost in thought that she did not see a man who was approaching. She was startled when a shadow fell on her and she looked up. There, standing before her, was her

husband, the rich man. He had managed to track her down!

"You thought I wouldn't find you?" he asked with a mean smile on his face. "I am going to teach you a lesson!" Before he could do anything, James appeared.

"Who are you, and what do you want?"

"I am here to take my wife back home."

"What are you talking about?" James was bewildered.

Aunt Annie had been waiting for the right time to tell James about her forced marriage and her subsequent escape.

When the man realised this, he quickly exclaimed, "This woman here is my wife and I am taking her back home with me."

James turned to my aunt and asked, "Is it true, Annie? Is this man your husband?"

My aunt tearfully explained, "That's not true. This man forced me to live with him. I don't love him and I am not going anywhere with him!"

James said to the man, "You heard what the lady said. Please leave before I beat you to a pulp."

The man tried to argue, "What about my cattle, goats and grain I paid for her?"

James moved slowly towards the man, his fists clenched, his face menacing. "Go and get your cattle and grain from whoever you gave them to." The man realised that he was no match for the young guy, so he scurried away and never returned.

Soon after that, James and my aunt got married. He took her to his parents' home in the reserves. Later, she left her in-laws and built her own home. She was such a hard worker, and with help from her husband she acquired some cattle,

goats and an abundance of grain. My mom and I used to visit her, and I remember we always thoroughly enjoyed our stays. There was always plenty of food.

Once when life had beaten me down and I felt I couldn't go on, I went to stay with Aunt Annie for three years. During that period, that's when she told me this story about her life.

Back in South Africa, my father was doing well at his job. The only problem was that he was beginning to feel lonely. At this point he was about thirty years old. He felt he wanted to get married and start a family, so he wrote home and asked his family to find a girl for him. This was common in our culture at the time.

Dad's family and Mom's uncle were neighbours. One of his sisters, Miriam, thought Mom was a great choice, so she approached her. "I have a brother who is in South Africa and he is gorgeous. How would you like to be his girl?"

Mom rejected the idea outright. "I don't know anything about your brother and I don't even know what he looks like, so forget it."

Aunt Miriam was determined. "I have this photo of him, and as for his character, you can learn about it when he comes." Mom took the photo and studied it. "Your brother looks way too old for me. As I said before, I am not interested."

After Aunt Miriam left, Mom's own aunt, her uncle's wife, called her. "Agnes, we need to talk," she said gravely. Mom went and sat with her, wondering what she had done wrong.

"I couldn't help overhearing you and Miriam talking," she began, "and I think you would be a fool to reject this guy."

Mom was annoyed. "I have good reason for rejecting him. He's way too old for me."

Mom's aunt talked to her persuasively. "His mature age is actually an advantage. Older men are more responsible. Don't let this wonderful chance slip through your fingers."

Mom gave the matter some serious thought. When Dad's sister came back, she was ready for her. "Alright, I'll be your brother's girl, but when he comes and I find I don't like him, I will reject him."

Word was sent to Dad that a girl had been found for him. He was overjoyed with this news and immediately travelled back home. When he and Mom met, they hit it off. My father was a charming guy, full of humour. Mom completely forgot about the age issue and they simply got on like a house on fire. A few months later, they were married. Dad had to return to South Africa and Mom remained behind.

Life was never easy for a bride living with her in-laws, especially in her husband's absence. Mom had a rough time of it. She struggled with the pressure of all the manual work heaped on her. To make matters worse, she was expecting a child. When her time for delivery neared, she went to Umtali General Hospital, where she gave birth to me. The minute I was delivered, the nurse handed me to Mom so that she could hold me for a few minutes. Then I was whisked away to be bathed and dressed.

Two hours later, another nurse brought a bundled baby to my Mom. One glance and Mom said, "This is not my baby. Why are you bringing this baby to me?"

The nurse argued, "That's your baby. You don't recognise her because she is all covered up."

On further examination, Mom discovered that the baby was a boy. She was agitated. "I know I gave birth to a robust baby girl, and where this tiny baby boy came from is a mystery to me."

Finally, the nurse took the baby boy away and later brought me to Mom. Whether the switch was accidental or intentional, no one will ever know.

Later that year, in 1946, Dad came home from South Africa. "I am not going back," he announced. "From now onwards, I am staying with my family."

"That's a relief to hear," Mom responded. "It was no picnic for me either."

They settled down to their married life. The field they were allocated was so small that Dad finished working on it in no time. The crops were sickly because of the tired soil. Generation after generation had been cultivating on the same piece of land, and as the families grew, the land shrank. The grain they harvested was barely enough to sustain them up to the next season. To Dad, the future looked bleak and he wanted more for his family.

One day he surprised Mom by saying, "Pack our stuff. We are leaving."

"Where are we going?"

"I don't know yet. I'll decide as we go."

They travelled to Umtali and headed straight for the train station where they took the southbound train.

Mom watched, fascinated, as the train passed the towns. It was her first time seeing the urban areas. Dad decided to settle at a place called Gwanda. This was in 1947 and I was a year old. The following year, Mom gave birth to twin boys.

They both died of measles after only nine months so I remained an only child and was thoroughly spoilt.

One day Mom had a pot of boiling water on the open fire she used to cook our meals. She went inside the house to get the mealie meal. It is said that I came hurtling from nowhere, stepped on a piece of firewood, which in turn levered the boiling pot, emptying the contents on my body. Mom came running out when she heard a piercing scream. I was instantly taken to the hospital. My burns were critical.

My mother was numb with worry since she had just lost her two other babies. She never left my bedside. As the days dragged by, my condition remained critical. One day a weary doctor talked to Mom. "I think you should go home and get some sleep before you get ill yourself. We can always call you if there is any change in her condition."

Mom wouldn't hear of it. "I wouldn't sleep anyway, even if I went home. I might as well stay here."

I gradually began to heal. I don't remember anything about this incident. Mom related it to me after I had asked her about the scars on my chest and arm. In 1950, when I was four years old, my brother Alick was born. Soon after that, my Dad decided to move from Gwanda. He got a job in Gwelo, but it didn't come with accommodation, so he quit after a couple of months. Once more we were on the road, and that's when we ended up in Umniati.

CHAPTER FIVE

"Pauline," Mom once asked me, "what would you like to do when you grow up? I mean, your real dream?"

I didn't think twice. "My dream is to travel to faraway places." I answered without hesitation. I had always had a yearning to see the places I read about in my books.

"You will need a good education for such a dream to come true," Mom advised.

In 1960, when I was in standard five, I didn't have to commute to and from Torwood anymore. Our distant relatives who lived in Amaveni offered me accommodation. Sometime that same year, our school choir had to go to Gatooma for a singing competition. I wasn't in the choir, but the choir master let me tag along to watch.

That was my first time seeing the town and I was fascinated. All the choirs from the area wore beautiful uniforms. When I went back home, I said to Mom, "How wonderful would it be if I attended school in Gatooma? I know it's out of the question, but I can't help dreaming about it."

Mom surprised me. "That can be arranged if that's what you really want. I have a cousin who lives there and I am sure she can accommodate you. Your real problem would be securing a place at the school." I couldn't believe my ears. This was too good to be true!

The following school break I went to Gatooma and sure enough, Mom's cousin, Mrs Bonomari, welcomed me. The only problem was that she was too busy to take me to the

school to try to secure a place for me. I felt let down and dejected, but I wouldn't give up without a fight. I asked her where the headmaster lived and she gave me the address.

"His name is Mr. Rukanzakanza," she supplied.

I went to the given address. I found a man outside the house working on some project. He was a short, slim man. He didn't look like a headmaster to me. My previous headmaster was a big, intimidating individual. This man greeted me kindly and asked, "How can I help you?"

"I am looking for Mr. Rukanzakanza."

"Well, that's me. What can I do for you?"

I sat down. In our culture sitting down is a show of respect, especially by women.

"I would like to secure a place for standard six in your school."

"You have to come to the school between 8 a.m. and 5 p.m. during weekdays. That's when we enrol pupils," the headmaster explained. "You also need to bring an adult with you."

My hopes were dashed! I started to cry.

"What's wrong?"

"I can't bring my parents because they live in Que Que," I replied sadly. "They can't afford the trip."

"Why exactly do you want to go to school here and not in Que Que?"

"I heard that your school is a government school and I won't have to buy books or pay any school fees. That would make things easy for my poor parents."

The man looked at me as I sat there with my tear-stained face. "Okay, you can come on the first day of school and

don't forget to bring your report card." He then took my particulars and that was it. I was in!

The year was 1961. The school was called Mupamombe Government School. It was situated at the edge of Rimuka high density suburb. The school was quite big compared to my previous one. It was awesome to have everything I needed for classes supplied for free. I soon learnt that besides the headmaster, there was a principal. His name was Mr. Deans. He was a white man who lived on his farm a few kilometres from the school. There was an arrangement between the principal and the government where his farm supplied and delivered cans of fresh milk to the school every day.

Every day at break time, little children would race to queue up and receive the milk. One day I asked a classmate who had been at the school since first grade, "Who exactly is eligible to receive that milk?"

"Anybody can have the milk, but we are too old for that. It's too degrading to be seen drinking milk like babies."

Well, I didn't think so. Afterwards, every day at break time I ran and gulped down at least two cups of milk. My classmates thought it was funny and laughed their heads off. I took no notice of them. Where I came from, milk was a luxury. I wasn't about to pass up the golden opportunity to enjoy the delicious drink.

During that year I became friends with a girl named Mary Nyamsona. She was always well kept. She had at least two sets of uniforms. I had only one and by mid-term, my shoes had holes in them, and a couple of my toes were sticking out. I knew Dad could not afford to buy me new shoes. He was having a hard time putting food on the table with his

stagnant salary and growing family after the addition of my young brothers, Mark and Chrispen. Nevertheless, I wrote a letter to my parents and lied that my shoes were stolen, and if I didn't have another pair, I would be kicked out of school. My hope was that somehow Dad would miraculously find some money and buy me a new pair. That didn't happen.

Instead, Mom offered me her old pair of shoes. Dad had to cycle the 70 kilometres from Torwood to deliver the shoes. Thinking back, I feel like kicking myself. That was totally inconsiderate of me to cause all that trouble to my dad. After delivering the shoes, my father made a U-turn and cycled back to Torwood. I later heard that he arrived around three in the morning. He managed to get little more than a few hours of sleep before he got up to start preparing for work.

My teacher's name was Mr. Kutama. Although he was a serious man, he was kind and helpful and I liked him. There was a big boy in my class whose name was Christopher. He liked to tease me by calling me cockroach because I was tiny. He would say things like, "Morning cockroach, how are you doing today?"

I always fumed at that and he seemed to enjoy it. I suppose I should have considered myself lucky because he didn't physically harm me. In those days many kids got beaten up by bullies and no one did anything about it.

When the year ended, I passed with good grades. At this point, there were no high schools in the black townships so I went back home.

Meanwhile, Dad was still struggling to make ends meet. One evening, he and his friend went on a fishing trip. His friend was the expert of this trade because he originally came

from Malawi, a country famous for its fishing industry. It was pitch black as they positioned themselves in the middle of the river, each holding one end of their fishing net. They gradually started moving towards the bank.

The net felt heavy and they felt confident they had made a good catch. The water came up to their shoulders as they slowly dragged the net. Suddenly, something hit Dad smack on the side of his face. He felt a sharp pain and let go of his end as he put his hands on the painful spot. His friend shouted, "Don't let go of the net!" but it was too late; the fish had escaped. Dad swam to the bank and sat down, still nursing the sore spot.

"Are you coming back or not?" his friend hollered from the middle of the river.

"No, I am not. My head is splitting. Let's just go home."

Dad's friend came out of the water and started to reason with him. "Look, I know you are hurting, but after the time and effort we have invested, we can't go home empty handed. Just think, right now your family is waiting for you to bring fish."

That did it. Dad went back into the water, pain and all. They brought home a sizable catch.

We all were oblivious of what Dad went through on these fishing trips. He told us about these incidents much later and we were shocked.

Our life was simple. At dinner, Dad and the boys ate at the table whilst Mom, my little sister and I ate in the kitchen, sitting on the bare floor. The dining room would later turn into the boys' bedroom. The table and chairs were shoved into a corner then they would spread their blankets on the

floor. Looking back now, I can see that we were better off than many families. There was complete harmony in our family. Dad and Mom never fought, unlike some of our neighbours. We felt secure.

Life continued to be a never-ending drag for me. As a school leaver, I had too much time on my hands. I had no access to any meaningful reading material. I had absolutely nothing to do besides household chores, or anything to look forward to. Once, a priest from our local church tried to be helpful by securing a place for me at Silveira hospital for nurse training. But when the long list of requirements came, things like a pair of sheets, a pair of brown shoes, a wristwatch and money for the fees, I knew it was out of the question. Dad could never afford it and I didn't even bother telling him about it.

On one particularly boring day, I visited a friend of mine. Her name was Ruth. When I got to her place, she had company. Another friend of hers, Renica, was with her. The three of us passed time building castles in the air. It was the only way we could brighten our monotonous existence. Our day dreaming was abruptly interrupted by Ruth's brother who breezed in with his friend, "Hi, girls! Would you like a bit of excitement?"

"What kind of excitement?" Ruth asked her brother.

"My friend here has just bought a car and we could take you all for a spin."

Up until that moment, I had never been in a car. The only thing I had been in besides the train was the double-decker bus which plied the Que Que-Torwood route. We all trooped outside.

Even to my inexperienced eyes, this was no car. It was a rattletrap! Phillip, Ruth's brother's friend, proudly sat in the driver's seat and started the engine. Billows of black smoke puffed out of the exhaust pipe.

"Come on everyone, hop in!" he called out.

Ruth's brother got in and sat beside his friend but none of us girls were willing to get into that ramshackle. "We will just drive as far as Redcliff and before you know it, we will be right back," Phillip said persuasively.

Renica was the one to give in first. "Girls, I don't see any harm in accepting this ride. I am sure we should be back in no time."

We piled into the heap and were soon rattling along. About halfway to Redcliff, Phillip said, "Is everybody ready for real excitement?" Before anyone could answer, he started to swerve the car sharply from one side of the road to another. We were thrown all over the place because this death trap had no seat belts! All three of us girls started screaming in fear.

If another car had come from the opposite direction at that exact time, a collision would have been inevitable. He finally righted the car and, miraculously, we reached Redcliff in one piece. My friends and I were all for making a U-turn and going back home. We just wanted to put this hair-raising ride from hell behind us.

"Okay, okay, let's go," Phillip said after we had pressured him.

Soon, we were on our way back to Torwood. We didn't get far though. The car made some funny noise, sputtered, and stopped. "I need all of you to get out and push while I try to

jump start it," Phillip told us.

We pushed and pushed until we were tired but the engine wouldn't start. There was nothing we could do but abandon the heap of junk and walk home.

By the time we reached Torwood, it was dark. *Time to face the music*, I thought to myself as I entered our house.

Sure enough, I got a good caning from my dad. In the days I grew up, parents used the rod before asking questions. I guess they were justified in doing so, because most children would lie through their teeth just to save their hide.

Things were so tough for many people that women formed groups to go and harvest wild mushroom in the nearby mountains. As more and more people hunted for the mushroom, it became scarce, so people travelled farther and farther away. On one occasion, a group of women were going as far as the Redcliff mountains. Since I was generally bored, and I fancied having mushroom for dinner instead of *muriwo*, I asked Mom for permission to join the group.

She was reluctant to let me go, "These people are planning to go too far away, and worse still, the mountains over there are too high."

"I am capable of walking the distance and climbing mountains just like any of them," I argued.

She finally let me go. When we reached the mountains, we spread out and started looking for the mushroom. I soon found that I could not keep pace with the group.

They were like monkeys, picking and climbing incredibly quickly. In no time, I was left well behind.

I was beginning to panic. All around me there was tall

grass and I couldn't see further than a couple of feet. I had no idea which direction the others had gone. I just blindly forged on. Suddenly, I came to a clearing. There, under a tree, waited one of the women. She had also failed to keep up with the group. It was such a relief to see her.

"Which way did the others go?" I asked, worried.

"I doubt that we can catch up with them," she answered. "I think maybe we should try to find our own way home."

We began to descend the mountain. At the base, we saw some tractor tracks. We followed them, with me leading the way. As we walked, I saw a straight black stick beside the track. It was about seven feet high. I made a beeline for it, planning to grab it and break it into a smaller size so that I could use it as a cane. The woman behind me let out a piercing scream and I instinctively ran past the stick.

"What is it?" I asked, startled. I thought she had spotted a wild animal.

"That snake!" She screeched. "And you just missed it by inches."

I looked around but didn't see anything. "Where is the snake?" I asked, thinking she was just fooling around.

"Right there in front of you," she said, pointing to the black stick. When I looked more closely, I saw that it was indeed a snake standing on its tail. Its tiny head was now turning this way and that. I turned and ran as fast as I could. I only stopped when I was out of breath. It was a close shave!

Although we were poor growing up, I was reasonably happy because my family was so close. My dad was a real comedian and he made us laugh most of the time. My brothers Alick,

Paul and I had a smooth relationship. We never fought. There was never any squabbling, bickering or sibling rivalry. I am very grateful for that because if those two had been aggressive, it would have made my life totally miserable.

One of the few forms of entertainment we had was cinema day. Once a week we were treated to some cowboy movies and comedy. Rough stone benches were built out in the open, and one wall of the Torwood hostels served as a screen. It was huge fun. We looked forward to these days. I always made a point of arriving an hour or so early to pick a spot where I would have a perfect view.

The annual Christmas festivities drew large crowds. Torwood township was made up of diverse cultures, so different groups came forward to perform, each, their own unique kind of cultural dance. This took place in the soccer field, a dusty patch of ground just outside the compound.

The event was turned into a competition. Always emerging in first place were the Shangani dancers. These men were very athletic. They jumped high in the air and landed on their backs and spun like tops. They stomped their feet so fast that it was mesmerising to watch.

Coming in close second was a Zambian cultural dance called Benni. These people wore uniforms like police winter tunics of the time. They danced to fast beating drums and made intricate steps in unison.

The Nyau dancers often grabbed the third place. This was a Malawian cultural dance. The dancers were always masked and no one recognised them. Some of them came on stilts and some would belly-dance while kneeling.

A fourth was a Malawian dance called chioda. It was an

all-female group. They wore beautiful Malawian attire and danced slowly in a circle, singing. There were other groups but these four were the most memorable. Each group danced twice before they were judged.

The compound manager, a white man by the name of Mister Greene, came over with his family and friends. A makeshift shed was made and chairs were arranged for them. That was one of the few times we ever saw the white people and all the kids shamelessly gaped at them.

These festivities took all day, and nearly the whole compound turned up to watch. We stood in the blazing sun, cheering and shouting in utter enjoyment. Afterwards, we would go back home to enjoy our Christmas dinner. This was the only day we would have rice, chicken and cokes!

Each family had its own way of coping with the poverty which plagued the majority of the black RISCO employees. For instance, there was a family that chose not to send their children to school. Instead, they bought themselves and their children nice clothes, and treated themselves to a luxury breakfast of tea and bread every morning. At the time, I envied these people, but now I dread to think of what became of those poor unfortunate kids without basic education. They could not even read or write. I thank God that my father was wise enough to know what was essential in the long run.

Some people sent their children to the rural areas, where they would live with their grandparents. The school fees in the rural areas were much lower and the headmasters there were lenient on the uniform rule. In towns, school uniforms were

compulsory. But, of course, it was hard on the kids to be separated from their parents.

Our neighbours to our right were having a much easier life. They had two kids, a fourteen- year-old boy and a two-year-old girl. Their standard of living was much higher than ours. Often this next-door lady called me to help her with housework, and as a reward I got to eat the leftovers from their previous dinner. Usually, it was beef stew with thick gravy sometimes accompanied by *sadza* or rice. What a feast! Unfortunately, the woman bragged about it, and despised my parents for having too many children they couldn't feed. That rattled Mom and they had a row. That was the end of my meals on the side!

"I have a burning desire to see my father," Dad said one day.

That surprised me because I knew of my grandfather's cruelty to Dad's mother. He himself had told me about it.

I voiced my thoughts. "Dad, how can you think of visiting your father after what he did to your mother?"

My father patiently explained, "In spite of what he did, he is still my father. Besides, the bible says in Mathew 18 verse 22, forgive others seventy-seven times." I didn't feel that way, but I kept my mouth shut. "You can come with me if you like," Dad offered.

Sure, I liked the travelling part, it had always been my dream from an early age, but I didn't relish meeting the notorious old man who was my grandfather. In the end, my passion for travelling won. I was also curious to see the place where my father grew up.

Dad bought some presents for his father: a blanket, some clothes and a pair of shoes. He had taken pains to save for this trip over a long period. For me, that was the most memorable journey of my life. We took a train from Que Que at midday and arrived in Salisbury in the evening. Along the way, Dad bought me all sorts of goodies which were sold on the train or at the various stations where the train stopped. At midnight, we took another train from Salisbury and arrived in Umtali in the morning. From there, we took a bus to Dad's rural home in Rusapi.

His older brother, Paul, welcomed us happily. After exchanging greetings, he took us to their father who was whittling a tree stump under a shade. "Dad," his older son called out, "Krispen is here!"

The old man stopped what he was doing and stared. "Is it really you Krispen?" he asked. His vision was slightly impaired because of age.

"Yes Dad, it's me," my father answered.

The old man slowly stood up and embraced my dad and wouldn't let go.

"Thank you for coming," my grandfather said to my father. "Now I will die a happy man."

Dad then presented his gifts. The old man sat down and cried. Afterwards he thanked Dad again for coming. We stayed for a whole week then returned to Que Que.

The whole family was happy to see Dad back. They had run out of food. Dad did his best to put food on the table. I don't know how he managed to do it, but he was just like a miracle worker. Later that week, Dad and his Malawian friend went for another one of their fishing trips. His friend

had heard of a dam some miles away which was teeming with fish. After two hours of cycling, they arrived at the dam. It was pitch dark. Dad's friend dived in. The water was unusually cold. He went down but the dam seemed to be bottomless. He surfaced and swam out from another part of the dam.

Dad, not knowing what happened with his friend, dived in too. He was shocked by the chill in the water. He too went down, trying to reach the bottom. He soon realised that even if he reached the bottom, the depth of the dam was not suitable for their kind of fishing. He surfaced and swam out. It seemed that they had been hoaxed. Some people who were jealous of their partnership and its achievements did it to spite them.

"We can't go back home empty handed," Dad said to his friend.

"I agree," his friend responded. The two cycled another hour to the river. They managed to catch a small number of fish. By the time they arrived home, it was almost time for Dad to go to work.

This meant that Dad had been up and about for 24 hours straight! The man was superman!

One day, a man came to our house to see Mom and Dad. His name was George (not his real name). Dad, Mom and George sat in the dining room chatting.

"I heard that you originally come from Rusapi?" George asked.

"Yes, we are," Dad answered.

"I also come from that area. We could be related, you

know?"

"It's a possibility."

From that day onwards, George frequented our house and most of the time the three would reminisce about their youth in their rural home.

A month later, George came with a proposition for Dad. He began by explaining, "I have been saving a bit of money each month. I hide it under my mattress." (There were no banks in Torwood then). "My fear is that someone might steal it since I share my room with two other people."

"So how can I help you?" Dad asked.

"I was thinking of lending the money to you. That way I would be assured that my money was safe," George replied.

"I don't think that's a good idea," Dad stated. "Right now, we are living hand to mouth. If you lend me the money, I wouldn't be able to pay it back."

"That won't be a problem," George reasoned. "I won't need the money any time soon. You can give it to me after a period of two years. By then your older sons will be done with their secondary school."

Dad finally agreed against his better judgement. The following day George brought the money, twenty pounds. At first, Dad resolved not to touch the money. "I'll just pretend that it's not there," he told us. But that was easier said than done. Circumstances arose which made it impossible for Dad to hang on to the money.

First, Mom got ill and she needed a good diet. Then Dad himself got ill and couldn't go to work for a week. His reduced salary couldn't tide us over the following month, so he dipped into George's money. After a few months, Dad was

left with twelve out of the twenty pounds.

"Since this money is slipping through my fingers, I might as well buy something we have been wanting," Dad said out of the blue. "I am going to buy a radio."

We were overjoyed. We used to go to our neighbours' houses to listen to music. Dad went and bought a small radio and in no time the rest of the money was gone.

A few months later, on Christmas day, we were all celebrating, eating rice and chicken when George made an appearance.

"Join us in our celebrations," Mom invited him.

"No thanks," he replied. "But I need to talk to you," he said to Dad.

"Is everything alright?" Dad asked, noting his seriousness.

"Everything is alright. I need to talk to you about that money I loaned you. Can I have it now?"

Dad was stunned. "You told me you would need the money in two years' time!" Dad pointed out.

"Things change," George retorted. "I now need the money, so I'll give you until the end of the month."

On pay day George came again and demanded his money. Of course, Dad didn't have it.

George was furious. He ranted and raved, but Dad kept his cool. It became a pattern. Every month-end George would show up, becoming more and more aggressive as the months went by. It depressed me to see my dad in such a situation.

CHAPTER SIX

I decided to go out and look for a job. I planned to send Dad as much money as I would so that he could repay George's loan. At first, my parents wouldn't hear of it. They were very protective of me. But when I persisted, they finally consented.

Finding a job proved to be an uphill task. I soon discovered that most jobs paid so little that it was almost impossible to sustain oneself let alone send anyone some money.

My first stop on my job-hunting adventure was Que Que. It was an eye-opener. I had lived a sheltered life so far, and I got a rude awakening. I secured a job in a restaurant on Second Street. Working in restaurants in those days didn't require any qualifications. The restaurants patronised by blacks didn't offer any variety on their menu. In the mornings, we made tea, sliced some bread and buttered it, and that was it as far as breakfast went. From noon till closing time, we served *sadza* and beef stew. We cooked a small quantity of rice for those who could afford it.

Our duties commenced at five in the morning. From there, it was non-stop work until closing time, around eight in the evening. There was no lunch break. We just grabbed food as we worked. A tiny room off the kitchen served as our sleeping quarters. It was rather tiny for the six of us, but we managed to squeeze together on the bare floor.

At four in the morning, a bell rang to wake everyone up and get ready for work. Then at five, another bell rang and we started work. All six of us did everything in rotation. For

instance, one day three girls would see to the cooking while the other three served the tables as well as cleaning up. The following day we would switch. The salary was about one pound ten shillings per month, hardly enough to buy a decent pair of shoes. I was determined to hang on to that job no matter what. I had to help Dad.

One day Mom showed up from nowhere. "I have come to take you home," she announced.

Some people had informed her that I was working under terrible conditions.

I protested, "Mom, I understand your concern, but I can't go back home with you."

Mom looked me over critically, then went out to a neighbouring shop and bought a head scarf. "Tie this on your head. Your hair looks terrible."

I accepted the scarf gratefully and tied it on my head. I knew my hair looked a mess. When the first bell had rung that morning, I was too exhausted to get up and groom myself. I only got up after the second bell rang and we had to start work.

I was so overwhelmed by my mother's love for me. That night my employer took me to task about the time I spent talking to my mother when there were dozens of customers waiting to be served. I tried to explain things to her, but it seemed to make her angrier. "If you think that it is so important to talk to your mother rather than serving customers, then go and talk to her for as long as you want, because you are fired!" I was more relieved than sorry to lose that job.

I landed another job as a nanny with an Indian family. I

wish I could say things improved for me at this point, but they didn't. The husband was always verbally abusive and if the wife answered back, she was physically assaulted. It was such a sad situation and it was very uncomfortable for me. What I gathered was that the wife came over as a mail order bride. When she arrived in the then Southern Rhodesia, she discovered that her husband was much older than her.

To make matters worse, he was extremely bad tempered. He expected her to jump at his every call. The wife resented this and was rebellious. This resulted in her getting frequent beatings. I know about all this because one day I heard the wife telling a stranger about it. In those days, servants were practically invisible, so employers felt free to discuss their private matters in their presence.

One morning when I arrived for work, I met my employer's wife as she came out of the house. She had some luggage. "I'm leaving," she told me. "I have taken all the beating I can." I stood there, open mouthed, as she and her two little boys walked away. My job had just ended without warning.

I decided to leave Que Que altogether and try the next town, Gatooma. I watched through the window as the train pulled away. I felt sad because I was putting more distance between me and my family. After a while, I became aware of a woman occupying the seat opposite mine. She had with her a little boy of about seven years. They were both well dressed.

I watched as they ate various kinds of food from their hamper. I hadn't brought any food with me and I couldn't afford to buy any. I was very hungry. The woman must have noticed because she engaged me in conversation.

"Where are you going dear?" she asked, smiling.

"I am going to Gatooma."

I was in no mood for small talk, hungry as I was. "Here," the woman said, handing me some food. "Please share with us."

"No, thank you," I refused reluctantly. It is customary to decline any offer of food the first time. But if the giver insists, one can then accept the food. The woman insisted.

"We have plenty of food here and we would be glad to share it with you."

I gratefully accepted. We talked as we ate. "My name is Mrs. Kawonza and my son here is Daniel."

"My name is Pauline."

"Where are you going Pauline?"

"I am going to Gatooma to try and find a job," I opened up.

"I live in Salisbury, and I am looking for a house girl," Mrs. Kawonza informed me. "How about you come and work for me?"

"I'd be glad to come and work for you."

When we arrived in Salisbury, we took a bus to Epworth Mission. Mrs. Kawonza was a teacher at the school there. My life with this lady was good. She was a fair employer and she treated me well. On Sundays, when I wasn't working, I went to the nearby balancing rocks. These gigantic rocks were so precariously stacked they looked like they could tip over any minute. But they were stable and seemed to be glued together that no matter what, they never moved an inch. The place later became a tourist attraction.

About three months into my working for Mrs. Kawonza,

I met a couple of girls at the balancing rocks. We started talking. "Why haven't I met you before?"

One of the girls, Deborah, answered, "We live in the city. We only come here to visit our father."

"Why don't you live here with your father?" I asked. "Because our mom passed away and our dad remarried," the other girl explained. "We don't get along very well with our stepmom."

I sympathised with them and our friendship grew.

"You know what Pauline?" Deborah said. "You could come to Salisbury."

"I don't think so," I quickly responded. "I am quite happy here."

"You could earn more money in the city," the other girl coaxed.

That got to me. I pictured myself earning a lot of money and sending most of it to Dad. "Where would I stay if I came to Salisbury?" I asked.

"My sister has a four-roomed house and would be happy to accommodate you," Deborah told me.

We agreed on a date that I would arrive in Salisbury and Deborah promised to meet me at Mbare bus terminus. That evening I told Mrs. Kawonza that I was leaving. She wasn't happy to hear it. She tried to persuade me to stay, but my mind was made up.

"Well, I wish you the best," she finally said. "And I want you to know that you will always be welcome in my home."

I felt sad leaving this kind woman, but I was on a mission to help my father. When I arrived at the Mbare bus terminus, there was no sign of Deborah. I looked around, overwhelmed

by the multitude of bustling people. I was really worried because I didn't know where to go. Deborah hadn't given me any address, so I was in a real bind.

Finally, I remembered that she had mentioned in passing that her sister, Kristine, worked in a hair salon on Rezende Street. I set out on foot towards the city. I located the street without any problem and began checking out all the hairdressing salons. I found Kristine in one of the salons further up the street. When I explained to her the whole story, she said, "Can you wait for me until I finish work?"

I was so relieved to know that Kristine was willing to take me to her home.

Later that evening, we arrived at Kristine's home in Mufakose township. It was on Muriranyenze Street. Kristine was a lovely person and she tried her best to be a good hostess, but I could tell she was struggling financially. She lived with her unemployed boyfriend and her two kids. The boyfriend was the babysitter whilst she went to work. I could sense that the last thing she needed was an extra mouth to feed. I silently vowed to get a job as soon as I could.

When I asked Kristine if she knew where I could get a job, she replied, "Your best chance would be to try the Arcadia suburb. I know the wages in that area may not be much, but it will be a start for you."

Little pay is better than no pay at all, I thought to myself.

With that in mind, I set off. My job hunting didn't bear any fruit. None of the potential employers offered accommodation with the job, which is what I wanted. I couldn't accept a job without accommodation because for one, I didn't know how long I would be welcome to stay at

Kristine's house, and secondly, commuting was costly and I didn't have the money.

When evening approached, I started out for Kristine's home. It was getting darker by the minute. I realised that I should have started out earlier since it was such a long walk. But I had got carried away with job hunting and walked much further than I had intended. I trotted beside the road. Cars were passing me by, but no one stopped to offer me a ride. I didn't know what would be worse, walking alone in the dark or getting into a stranger's car at night.

About an hour into my walk, I heard some voices. A group of people was coming towards me. I felt this wasn't good, but I didn't know what to do. I bravely walked on, praying that the people were harmless and would leave me alone. A few minutes later, three figures appeared in front of me. I could tell they were drunk by the unsteady way they were moving.

They appeared startled to see me and asked who I was. Suddenly, one of them slapped me very hard and I fell. The others joined in kicking me until I blacked out. They left me lying unconscious by the side of the road.

When I came to, it was light. I think it was around four or five in the morning. I was feeling terribly cold. I struggled to get up and my body ached all over. I walked slowly down the deserted road. I felt I wasn't going to make it home, but I couldn't give up without trying. Then a miracle happened! A car stopped. "Can I give you a ride?" a man called out.

At this point I had no choice but to accept the ride. This Good Samaritan asked me for directions when we arrived in Mufakose and he delivered me to Kristine's house.

"What happened?" Kristine asked, horrified by my swollen face.

When I told her what had happened, she said, "It's a miracle that you are alive at all. Not a day passes without a body found along that road."

I stayed with Kristine until I completely recovered. I then decided to admit defeat and go back home to my family. Mom was thrilled to see me. She told me, "Last week on Monday I had a horrible dream. In the dream I saw you lying there, dead. I cried so hard until my voice became hoarse. When I couldn't cry anymore, I started to pray. I was so relieved when I woke up and realised that it was only a dream."

To my surprise, the day she mentioned was the exact day I was left for dead by the roadside. I stayed with my family for a couple of months. During this period, I noticed that things hadn't improved financially.

Dad had resolved the issue of George's loan by having his employers deduct a certain amount from his salary each month and give it to George. This didn't do any good to his already stretched pay cheque. Mom would make a small packet of dry beans last four meals. My brothers had to count out the beans to ensure that everyone got the same amount. Sometimes Dad would buy a packet of sour milk to be used as relish for our *sadza*. He would pour the milk into a bowl then add water to it to increase the quantity. This didn't taste good at all but we had no choice. Once more I decided to go out and look for a job and try to help Dad.

I told Mom about it and she tried to be helpful. "I have a cousin who lives in Gwelo. He owns a grocery shop. He

might employ you."

I was optimistic. "Can you give me his address?" I asked excitedly.

"Well, I don't have it. But his name is Mahari. You shouldn't have any problem finding him because he is well known."

With that, I embarked on my journey. The train arrived in Gwelo at two in the morning. I slept in the waiting room at the train station. When morning came, I walked to Monomotapa Township. I entered the first shop I saw.

"Can I help you?" the man behind the counter asked.

"I am looking for my uncle. His name is Mahari. Do you by any chance know him?" I asked hopefully.

"No. Never heard the name. Do you have his address?"

"I am afraid I don't," I replied with a sinking feeling. "What I know is that he owns a shop."

The man looked at me as if I had two heads. "Maybe you should go to the community centre. They may be able to help you."

He gave me directions and I was there in no time. I gave my name to the person in charge at the community hall as well as my uncle's name. A few minutes later, I heard his voice booming over the loudspeakers, "Mr. Mahari, Mr. Mahari please come down to the community centre and get your niece, Pauline from Que Que."

These loudspeakers were scattered all over Monomotapa Township. After the announcement, music burst from the speakers. This was a source of entertainment for the residents. Very few people had radios of their own at the time.

I sat patiently, enjoying the music. At intervals, the music would be interrupted by all sorts of announcements, including the one asking my uncle to come and get me. The day dragged on, and there was no sign of my uncle. I began to get worried. At about six in the evening, the loudspeaker man said to me, "I will be closing down in about an hour and I doubt your uncle will turn up. You better think of some place to go."

That's when I really panicked. The only place I could think of spending the night was the train station, but since it was already dark, I couldn't walk there alone. About halfway to the station, there was a graveyard. This shadowy area was notorious for muggings and murders. It would be utter folly for a girl of my age to attempt the walk. As I sat there, almost in tears, a guy approached me. "Are you Pauline?" he asked me.

"Yes, that's me," I answered promptly, thinking that my uncle had finally come to get me. "Are you my uncle Mahari?" I hadn't met my uncle before.

"I am afraid I am not. But my sister and I can put you up for the night."

My heart sank. I was filled with doubt and fear as I looked at the man. How could I possibly trust this stranger? How was I to know if there was a sister at his house at all? What if this stranger lured me to his house then attacked me?

The loudspeaker man eased my mind a bit by saying, "Don't be frightened. I know Robert and his sister. They live down the block."

I didn't have much of a choice except to trust them. Luckily, when I got to the house, Robert's sister welcomed

me. She was about my age and we hit it off. Her name was Ella. The house had five rooms and Ella and her brother occupied a room each. The other three rooms were taken up by three other families. One of the families had seven members.

I had never seen such a crowded place before. The following morning, I went out job hunting. The previous night, Ella had generously offered me accommodation until I got a job. I chose to start with the shops and restaurants opposite Batanai Bus Terminus. These shops and cafes were always so busy that I was very optimistic I would get a job.

That didn't happen. As I went into one restaurant after another, the answer was always, "Sorry, we are not hiring at the moment." It was so disheartening. I decided to go into one last shop before I called it a day. To my surprise, the man behind the counter showed some interest when I told him I was looking for a job.

"Are you a hard worker?" he asked.

"I am not afraid of hard work," I answered.

"Follow me." The man climbed the stairs at the back of the shop. We went up two flights, and when he opened a door, we were in what was clearly the family's residence. The place was a hive of activity. A couple of women were by the stove cooking something, one was by the sink, another was crooning to a baby on the couch, and some were dancing to loud music. It was quite a crowd! At first, I thought I had walked into a party. Well, it wasn't. It was family, extended family, as well as house guests.

The man left me in his wife's hands. "Come and I will show you what you have to do if you take the job." She took

me to the laundry room and showed me a mountain of dirty clothes. They had to be washed by hand, dried outside and ironed. After laundry, I would then do the general cleaning of the whole house. I could see that the job was a handful, but I decided to take it.

The following morning, I started my workday by attacking the enormous pile of laundry. It took me at least three hours, washing one item at a time, rinsing the whole lot, then wringing out the water one item at a time. While the clothes were drying in the sun, I started with the cleaning. First, I went to the bedrooms. The numerous beds were all unmade. I ran around making the beds as fast as I could. From there I cleaned the lounge and dining room. By the time I went into the kitchen, the sink was piled high with dirty dishes.

After I was done with the kitchen, I went out and retrieved the laundry and started ironing. All this time the woman was at my heels, breathing down my neck and sometimes yelling if I did something the wrong way. It was quite nerve-wracking. The routine was largely the same in the following days. After my sixth day, I couldn't take it anymore.

"I won't be coming to work tomorrow, because I have decided to quit," I notified my employer's wife.

"Is that so?" she responded, unperturbed. "Well, I am not stopping you. The door is open."

"Can you please pay me for my six days' work?" I asked humbly.

"You want me to pay you?" she asked in mock surprise.

"Yes, I do," I was bewildered by her reaction.

"Wait here." She disappeared into a side room.

In no time, she was back with an armful of baby clothes. She put them down then picked them up one by one saying, "You burnt this, and this, and this," as she displayed scorched parts. "That is why I won't pay you," she declared. Clearly someone had scorched the clothes while ironing them but it wasn't me!

She kept those damaged clothes solely for the purpose of accusing unsuspecting employees, so that she could wriggle out of having to pay them. It was outrageous.

I walked away, defeated. The next day, as I sat brooding over my misfortune, Ella approached me. "Can you accompany me to that big house behind Ascot school? I'd like to buy some fresh vegetables."

"No thanks. You go ahead." I was in no mood for a leisurely walk. I just wanted to be left alone to wallow in my self-pity. But my friend would not take no for an answer.

"The walk will do you good," she coaxed. "Besides, it will pass the time, you know."

I finally agreed, "Okay, if you insist." I put on my shoes. It turned out to be a pleasant walk. We reached the house, bought our vegetables and started back to our place. As we were passing Ascot school, I spotted a familiar face in the school yard.

"That guy over there was my classmate," I told Ella. My friend thought I was kidding. "His name is William Banda," I said, trying to convince her that I was telling the truth. At that moment the guy looked our way, and he recognised me too.

"William, what are you doing here?" I asked as he came over to where we were standing.

"I am a teacher here," he informed me. "I have been teaching for two years now. What about you? What are you doing?"

"I am not as lucky as you are. I have been looking for a job without success."

William was sympathetic. "Don't lose hope. Things will turn out well for you when the time is right," he encouraged. I thanked him and we parted.

It made me sad to see that some of my classmates had made it in life, whilst I was struggling. Life seemed so unfair!

Ella and I walked down the road in silence with me lost in my thoughts. I was brought back to the present by someone calling my name from behind us. I turned and was surprised to see an ex-schoolmate of mine. *What a coincidence!* I thought to myself. *Meeting an ex-classmate and an ex-schoolmate, all in one day!*

"Hi Sonia," I responded to her greeting. "You live here in Gwelo now?"

"No," she replied. "I work in Bulawayo. I'm just here to visit my cousin. What about you? How are you doing?" She seemed genuinely interested to know, which was funny because during our school days we never spoke to each other. She was a class above me and our paths never crossed.

In response to her question, I briefed her about my unfruitful job hunting. "I think you'd have a better chance of finding a job if you came to Bulawayo," she said helpfully.

"You mean you can stay with me until I find a job?" I asked hopefully. It would be out of question for me to go to Bulawayo when I didn't know anyone in that city who could accommodate me.

"I'm afraid my employers don't allow me to have any guests in my boy's *kaya*. But I have an uncle who would gladly accommodate you. I could wait for you at the train station and take you straight to my uncle's house." After agreeing on a date for my arrival, we parted. Ella was not happy about this whole arrangement.

"I don't think it's a good idea for you to go to Bulawayo. You are too young to be walking the streets of that city alone, looking for a job."

I wasn't to be deterred. "I am nineteen years old, and I am capable of taking care of myself," I argued. "Anyway, my mind is made up." I was determined to find a job, and my mind was laser focused on that goal. On the appointed date, I arrived in Bulawayo and sure enough, Sonia was at the train station as promised. She accompanied me to Tshabalala and introduced me to her uncle and his wife. These two were the kindest people I had ever known.

They were good to me even though they were not well-off. The house was bare of any furniture, and some windows had broken panes. There were several other people living in the house. I found out that some of them were relatives and some were friends of relatives. The male occupants of the house used empty Coca-Cola cases as stools, and the ladies sat on the floor.

Later that evening, after dinner, as we sat chatting, I asked if anyone knew where I could find a job as a house girl. "Which suburb has more possibilities?" I asked.

"You won't find any job if you go knocking on potential employers' doors," Sonia's uncle advised. "These days no one is likely to employ a stranger who just shows up at their door

for fear of being robbed. Some people pretend to be looking for jobs when, in reality, they are thieves. Your best bet is to go to the employment agency." It was somewhere in the light industrial area. I had to get up early in the morning because it was a long walk away.

CHAPTER SEVEN

I didn't have any money for transport to go around. The small amount I was hanging onto was for my train ticket back home if things didn't work out for me. I arrived at the employment agency at about eight in the morning.

There was a large crowd of people milling about. I went to the clerk and had my name registered, then went to sit down and wait. Every now and then, a potential employer would come and a couple of names from the register would be called.

It was such a painfully slow process. *At this rate, it will take a year before my name is called!* I thought to myself. It was so frustrating. At about lunchtime, a few people went to a nearby kiosk and bought food. But most, including me, had to settle for 'air pie'. The hours ticked by slowly, and at the end of each day I would walk back the long distance to Tshabalala.

The year was 1965. One day, after I had been coming to the employment agency for a week, an older woman sat next to me and started talking, "It's unbelievably hard to find a job these days. If my name is not called in the next couple of weeks, I am giving up and going back to my rural home to till the land," she said dispiritedly.

"I feel the same. I am beginning to wonder if it's worth my while to stick around this place any longer."

The woman looked at me for a moment and then asked, "How old are you?"

"I am nineteen," I told her, wondering what my age had to do with anything.

"Then why do you come here? There is a place which caters for teenagers," she informed me.

"I have never heard of such a place," I replied, not believing what she had told me.

"It's called Mpopoma Youth Centre," she said and gave me directions to the place.

Straight away, I set out and found the place without any difficulty. There were not many people around, and the place looked so clean. When I told the first person I saw about my job hunting, he said, "Come with me," and led me to a room with several girls my age and a lady counsellor. The counsellor welcomed me warmly, and the other girls were nice too. My spirits lifted. I wished I had known about this place earlier.

My name was listed, and I was told that I was number sixteen. Things were finally looking up! We sat on comfortable chairs, and to my utter surprise, tea and scones were served. I couldn't believe my eyes. I pounced on the scones and gulped down the tea so fast that everyone was staring. I didn't care. I was hungry. Later, the counsellor took me aside and asked about my background.

I told her a bit about my history, how I had been walking from Tshabalala to the employment agency in town and back, two hours each way, and how someone at the agency had told me about the youth centre. The counsellor was moved by my story. She told it to the other girls and they were all sympathetic towards my situation. The girls came from Mpopoma and the nearby Njube Township. None of them walked a long distance.

At about 4 p.m. the counsellor said, "Pauline, since you

are walking to Tshabalala, I think you should go now. I wouldn't want you to walk alone after dark." I thanked her and walked home with a lighter heart. I arrived around 6 p.m. I looked forward to coming to the youth centre the following day, leaving home at 5 a.m. and arriving around 7 a.m. when it opened.

Whilst waiting for potential employers to call, our time was filled with activities such as sewing and embroidery. Several days later, when there were about seven names ahead of me on the register, the kind counsellor talked to the other girls, "Can you please allow me to break the rules and send Pauline to the next employer who calls?"

She still felt bad about the distance I had to walk every day. The other girls agreed. That very day, a man called asking for a girl to work as a cashier in his grocery shop. "We will let you have this job," the counsellor told me as she gave me a written address of my employer-to-be. As I looked at it, I saw that it was in the next township, even further away from Tshabalala. I could see a real problem looming.

I had specifically registered for a job as a housegirl because that job usually came with accommodation. However, I didn't have the heart to point that out to the counsellor. She was doing her best to help me and I didn't want to seem unappreciative.

When I arrived at the shop, the proprietor was out. I was told to wait outside and I would be called when he returned. I sat there alone with my thoughts, wondering how things would turn out.

By six in the evening, he still had not returned. I became very apprehensive because I should have been on my way by

then to reach Tshabalala before dark. Finally, the man came back and I was called in for an interview. Immediately, another obstacle I hadn't foreseen arose. It was the issue of language barrier.

Bulawayo is a Ndebele-speaking city and I was a Shona-speaking person from the other side of the country. "How can you expect to communicate with my customers if you can't speak the local language?" the shop owner asked reasonably. Understandably, I didn't get the job, so I started my long walk to Tshabalala. It was dark by then. If I was apprehensive before, that was nothing compared to what I was feeling now. I was in full panic mode, sending up a silent prayer for my safety.

Mercifully, I finally reached the outskirts of Tshabalala, but I could not breathe a sigh of relief yet. I still had a long way to go and the streets were unlit. As I walked along the narrow, dusty roads between the houses, I spotted a man behind me, going the same way I was going. *Where did he come from?* I thought to myself. This didn't look good at all. I broke into a run, darting in and out of the dark lanes, but still I couldn't shake him off. It became obvious that he was following me.

My heart was now pounding like a sledgehammer with fear. When I was about a couple of blocks away from my destination, the man caught up with me. By then, I was shaking like a leaf. "Hand over the money and make it quick!" he ordered.

"I don't have any mo..." Before I could finish the sentence, he punched me and I fell to the ground in a heap.

"Don't waste my time, give me the money now!"

I knew there was no reasoning with that crazy person, so I just lay there, crying. My only hope was that someone from one of the surrounding houses would come to my rescue.

That didn't happen. When the man saw that I didn't have any money, he got angry. He kicked me viciously. "What do you think we live on?" he hissed, as he finally disappeared into the dark.

It was a miracle that I survived that savage attack. After a while, I painfully rose and wobbled the two blocks to our house. When I staggered into the house, Sonia's aunt gasped in shock. "What happened to you?"

I burst into tears and couldn't answer her. She helped me to bed and gave me pain killers.

The following day I couldn't get up. My whole body was in agony. Sonia's aunt kindly cared for me. I am forever indebted to that woman. I only wish I could find her and thank her properly for what she did for me that long time ago.

On the day I was able to get up, my first thought was of getting out of that city as fast as I could. However, I didn't feel like running back home to my parents. They had enough on their plates as it was. So, I went back to Gwelo and stayed with Ella. It was during this period that I had one of the most memorable turns of events in my life.

CHAPTER EIGHT

Ella and I had gone to the house behind Ascot school to buy some fresh vegetables. As we were leaving the house, a car drew up. We watched curiously as two men got out. One was bulky and the other was of medium build. The bulky man looked vaguely familiar, but I just couldn't place him. He called out to us, "Girls, do you happen to live nearby?"

Ella answered, "Yes, we do."

The man came closer. "Do you happen to know anyone in the neighbourhood looking for a job?"

"Yes, as a matter of fact both of us are looking for jobs."

"That's great!" the man exclaimed. "You are both hired! Are you prepared to travel?"

"I like travelling," I answered eagerly.

"By the way my name is Jairos Jiri, and I need girls to sing in my band," he told us.

I couldn't believe my ears. It was a dream come true for me. I had always dreamt of becoming a singer. Besides, Mr. Jairos Jiri was such a famous man and it would be an honour to work for him. Travelling would be a bonus. I told Mr. Jiri straight away that I would be glad to take this job.

However, Ella was not interested in the travelling part. Mr. Jiri was not aware of this, so he said, "Girls, go and pack your bags and be here by seven in the morning."

Ella and I walked back to our place and I packed my things. By seven in the morning the following day, I was at the house. I later learnt that it was Mr. Jiri's second home.

I joined the band at a small mine called Patchway, just

outside Gatooma. Mr. Jiri himself took me there and introduced me to the band, the 'Jairos Jiri Key Knots Revellers'. I wondered who came up with that strange name. The year was 1966 and I was twenty years old.

In addition to Mr. Jiri, there were seven other band members. First there was Stanley. He was the band manager and was related to Mr. Jiri. He was a serious, no-nonsense guy. Stanley always travelled ahead of us and booked venues for our shows and hung up posters advertising the dates and times for them. Then there was Prosper Ngwenya. He was the band leader and the lead guitarist. He was a very handsome young man but very reserved. Nduna Sibanda was the bass guitarist, and he was blind. He was on the quiet side but if anyone started a conversation, he would participate good-naturedly. He was such a pleasant guy. William was the rhythm guitarist, and he was also blind. He was a very cheerful and likeable person. Then there was John Sakala, blind as well, and he played the penny whistle. On the drums there was Tito, and on male vocals there was Pio. I think that was short for Pious.

All the band members except me had their homes in Bulawayo. Although the majority of us were Shona, we all adopted the Ndebele culture of using totems as our surnames. I introduced myself as Pauline Sibanda. My last name, Magosvongwe, is a mouthful anyway.

There was a sister band, but I didn't know much about the members because we went our different ways. The only two people I knew from the other band were Fanyana Dube, the lead guitarist, and a guy known as boy Masaka. This other band was just known as Jairos Jiri Band. This was way before

the Paul Matavire era. There were two other people who travelled with us. One was the owner of our hired van, Joseph and the other was the driver, William.

Mr. Jairos Jiri was a man held in high esteem in the country because of his good work. He was born in Bikita in the Masvingo province. When he came to Bulawayo as a young man, he was moved by the plight of the blind and disabled people in the city. On almost every corner, there was one begging for money from passers-by. He founded the Jairos Jiri Organisation in 1950.

Following Christian principles, he helped these disadvantaged people by training them in craft work, carpentry and other things. He found ways to market their products overseas. The bands were also a source of income for the organisation. I quickly practised some songs with the band. I couldn't compose my own songs, so I picked out some popular hits of the time. One of them was called 'My boy lollipop' originally sung by a girl named Millie Small.

From Patchway we travelled from place to place doing our shows until we made a stop in Salisbury. While we were there, a girl named Lois joined the band. I was thrilled. Lois and I got on very well, and we now shared the duties like cooking and generally taking care of our blind members.

We stayed for about a month, doing shows in the high-density suburbs such as Mbare, Dzivarasekwa, Rugare, Highfields, Mabvuku, Chitungwiza, Kuwadzana, Seke and Warren Park. During this period we lived in a rented house in Mufakose. From Salisbury we went to Umtali, stopping for two shows along the way. My most memorable show took place in Umtali. The venue was Beit Hall. This theatre was so

large, and on that day, it was almost filled to capacity. Every one of our acts received a thunderous applause. We all felt good after that show. It was such an exhilarating experience, and I will always treasure the memory.

We always followed the same program for our shows. The band would warm up by playing instrumental music for about thirty minutes. John Sakala would then play some songs with his pennywhistle which was very popular at the time. Lois went in with her three songs. I went in after Lois. After a short break, Lois and I would do a duet. Finally, Pio would treat the audience to some rock and roll music.

It was a great variety show and the audience loved it. The pay was good too and I planned to send my dad most of it. But when Stanley gave me my first pay packet, we were at a remote place with no access to postal services. I tucked the envelope with my pay into my suitcase, between my clothes. When we later reached town, I looked in my suitcase for the money, but it was not there! Someone had stolen my whole pay! I broke down and cried. It was a painful experience.

Later that week we left Sinoia for Hartley. "I think you need a new wardrobe," Lois noted as we were getting ready for a show.

"Well, I know that" I answered defensively. "It's just that right now I need to send my dad some money."

Lois was persistent. "Nice clothes can do wonders to your confidence and enhance your performance."

I got her point. Lois, having lived in the city all her life, had an impeccable sense of fashion. My clothes looked drab next to hers. When I got my pay that month, I splurged on my new wardrobe. I vowed to send Dad my following pay

cheque. I didn't get around to doing it though, because the thief struck again. My whole pay packet went missing! Just like that. I had an inkling as to who was doing that to me, but since I had no proof, I kept my suspicion to myself.

As we toured the midlands, I began to miss my family terribly. I hadn't seen them in about nine months. Then, out of the blue, Stanley said, "We are doing a show in Torwood on Saturday." That was the best news I had had for a long time. I was bursting with excitement and anticipation for the family reunion. Then I remembered that I had no money to give them. My excitement evaporated. "Go and borrow money from Stanley," Lois advised.

I hesitantly approached Stanley. "Can I please borrow money to give to my family?" I begged.

"I just paid you last week. What did you do with the money?" Stanley asked.

I didn't want to tell him about the thief, since I couldn't be sure who it was, and I didn't know how else to explain my predicament, so I just started crying.

"Okay, okay," Stanley soothed. He was a kind-hearted man. "How much do you want?" I named a sum, about half my salary. "Here you are," Stanley said, handing me the money. "But I will deduct the money from your next pay."

When I handed the money to my mother, she was very grateful. She gave me an update on the latest developments at home. "Things are tough especially now that two of your brothers are in secondary school. Their school fees are deducted from your father's pay, and there is not much left for our other needs." It was a bleak situation.

We did one show in Torwood. Stanley let all my brothers

and their friends in for free. My mother attended the show too. From Torwood, we went to Gwelo. I tried to look up my friend, Ella, but she was no longer living at her old residence. She and her brother had left and no one had their forwarding address.

After several shows around Gwelo, we proceeded to Bulawayo, stopping for a couple of shows along the way. Everything was good. The only fly in the ointment was that one of the blind band members had a drinking problem, which resulted in him having anger management issues. Whenever he had some alcohol, he would fly into a rage, and usually he would pick a fight with someone.

One day, when this guy came back from one of his drinking sprees, he targeted me. I felt that it was high time someone stood up to him, so I gave him a piece of my mind, confident that he wouldn't hit a girl. I was wrong!

Like lightning, he struck the side of my face really hard. I reeled back and fell in a heap. The blow knocked the wind out of my sails. Instantly, my face began swelling up.

That night I did not perform in the show. I spent the evening nursing my throbbing face. Several months later, the guy did it again. That time we had just arrived in Chirundu. He jumped out and made a beeline for the local drinking hall, and straight away started drinking. About half an hour later, he came back into the van, a beer bottle in his hand. The rest of us were still sitting in the van, chatting. As expected, he got insulting.

Joseph, the owner of our rented van, couldn't stand it any longer so he told the guy off. That was a wrong move. The guy smashed the beer bottle he was holding into Joseph's

face. The bottle splintered and practically sliced the poor guy's face. I was sitting right next to Joseph and some blood splattered onto my clothes. Joseph was taken to the local clinic where the staff tried their best to suture his face. It was a pretty bad situation.

Occasionally, Mr. Jiri would travel with us. He was such a humble man that he would refuse to take the seat next to the driver, choosing to sit with us in the back of the van. We loved those times because he would amuse us with stories as well as very funny jokes.

During this whole period, I learnt a lot about blind people. They are independent. When I started working with them, I thought I was there to do practically everything for them. But I was surprised that they were determined to do almost everything by themselves, including hand washing their clothes.

Another thing I noticed was that they have a very sharp sense of hearing, and a remarkable memory. They can tell who the person is, just by their voice or by their step. Blind people don't like to be pitied. They just want to be treated normally and I learnt all this pretty fast. One day, soon after I joined the band, Nduna was tapping his way to the toilet. I took his hand to guide him and he brushed me away. He successfully reached the toilet unaided

One day, I woke up feeling ill. As the days went by and we continued with our tour, I felt worse. When we were in Selukwe, a new girl was brought in to replace me. That came as a shock. I loved my job so much and the last thing I wanted was to be replaced. This girl's name was Virginia and she was very pretty.

To cap it all, she had a beautiful voice. When she performed in our show that evening, I knew I had lost my job. It was one of the saddest days of my life. I went to Gwelo and finally tracked down my friend Ella. I didn't feel like running home to my parents. They had enough on their plate as it was.

CHAPTER NINE

I felt very sad after I lost this rare job. As the days went by, I became very depressed. One day, in the midst of my gloom, I impulsively wrote Mom a short note. Although I didn't say much, my mother, like most mothers, read between the lines and detected my distress. She responded by sending my little brother, Chrispen, to me. At six years old, my little brother was an exuberant character. He was a chatterbox too. Mostly he was funny and I found myself laughing hard a lot of the time.

I soon forgot about my problems and my days were centred around taking care of Chrispen. He was a model child, very helpful and very mature for his age. However, I realised I couldn't live with Ella forever. That would be taking advantage of her kindness. I finally decided to go back to Torwood, and my parents were glad to see me.

"It's a good thing that you came," Mom gushed. "Your timing was perfect! We are leaving for Gokwe, and I can definitely use an extra pair of hands."

Gokwe is a rural area some 140 kilometres from the town of Que Que. Some decades earlier, in the fifties, the government at the time had scouted this large landmass and discovered it was scarcely populated. That's when they decided to remove some of the black indigenous farmers from parts of the midlands and settle them in Gokwe.

Things were tough for those first settlers. Communities were settled in the middle of nowhere without shelter, and mosquitoes feasted on them. Some died of malaria. Tsetse flies also preyed on their stock and much was lost.

However, the people had amazing resilience. They worked very hard, clearing the land for agriculture and planting various crops. Several years later, they were harvesting surplus and selling it to the Grain Marketing Board. The more adventurous ones ventured into cotton growing.

This crop turned out to be a real money spinner. Some people started to build themselves big brick houses, and some even bought cars. All this brought popularity to the Gokwe area. That's how my mother got to know of the place. After several trips to Gokwe, Mom managed to secure some land and planned to work hard in order to supplement Dad's meagre salary.

My brothers Alick and Paul remained with Dad in Torwood because they were going to secondary school. There were no secondary schools in Gokwe at the time. My sister Maggie, myself, and my three brothers, Mike, Mark and Chrispen, started our new life in Gokwe. It was quite an experience. For us kids, it was the very first time to ever live in a rural area. There was only one hut standing and it had no door.

"Where is the bathroom?" Mark asked.

"I am afraid there is no such a thing as a bathroom here" Mom explained gently.

Life in the rural area was tough, but I for one was glad to be of some use. First, we had to clear some land for cultivation, but the trees were huge and usually tree cutting was known to be a man's job.

"What are we going to do?" I asked Mom, worried. Clearly Mom and I couldn't even attempt to cut the trees.

"I have an idea," Mom replied. "We will make a small fire

at the bottom of a tree and keep it going until the tree falls."

We put Mom's idea into action and it worked! One by one, the trees fell. By the time the rains came, we had a considerable patch ready to be ploughed and planted.

At that point, our diet was worse than ever. All we had was a bag of mealie meal and a packet of sugar. We would wake up early in the morning and work on the land up to about noon, then sit for our first meal. We would go back to work until sunset, then have our dinner, which was always *sadza* with *musone*.

Dad sent Mom a small amount of money every month-end and she would use it for basics such as soap and kerosene for our lamps. When schools opened, all my other siblings went to school, and that left only Mom and me to do all the work. Not that the others were having it easy. The school was at least eight kilometres away and sometimes they had to walk the distance in the rain with no umbrellas or raincoats.

One morning, my siblings couldn't find the matches to light the lamp and prepare for school, so they had to do it in the dark. They managed to locate their clothes, but my young brother, Chrispen, could not find his belt. In the dim light, he finally saw something which looked like a belt and picked it up. It wriggled in his hand and he threw it down, screaming. It was a snake! There was pandemonium as everyone jumped and rushed for the door. A neighbour later came to get rid of the snake for us.

The crops did well and after the harvest, our diet improved considerably.

"Now that you are well settled, maybe I can go out again and look for a job," I told Mom one day.

Mom agreed. "I think it's a good idea. This life here is no life for a young girl."

I chose to go to Umtali. It was one of the towns where I hadn't tried my luck in job hunting. I planned to stay with my Aunt Veronica, who lived in a suburb called Devonshire. She was my dad's half-sister from a different mother. Unfortunately, as I was arriving, my aunt was leaving. She was going to the hospital to await the delivery of her baby. The house girl didn't know me, so she was barely civil to me.

The following morning, I walked to town to try and get a job. After an unsuccessful day, I returned to my aunt's home. It was a long walk, especially after pounding the streets all day long.

"Hi there. How far are you going?" a voice from behind me called.

I snapped out of my reverie and saw a tall, pretty girl with a very light complexion. "Hi," I responded. "I am going to Devonshire."

"Well, we are in luck," she said, smiling. "We are going to keep each other company as we walk. I also live in Devonshire."

I liked her instantly.

"My name is Irene," she introduced herself. "Irene Antony David in full."

"Mine is Pauline," I told her. As we walked, our conversation centred on jobs, particularly their scarcity.

"I have been looking for the past six months to no avail," Irene told me. "I am just about to give up."

My heart sank. If this girl who'd lived here all her life couldn't find a job, what chance did I have? We shifted to

more cheerful topics like books and movies.

When we were about two blocks from my aunt's house, Irene stopped, "This is our house. Please come in and meet my family."

I agreed. Her whole family was as friendly as she was.

"This is my mom, my dad, my sister, my brother, and this little tot here is my daughter," Irene said, picking up a little girl.

"Please join us for dinner," Irene's mom invited.

Although I was starving, I automatically said no. Food was not in abundance during this time. People were struggling to put any on the table, especially in the urban areas. At the same time, it was cultural to invite a guest to share your meal even if you didn't mean it. Irene's mom insisted, together with the rest of the family. Their invitation seemed genuine, so I finally agreed to share their meal.

My friendship with Irene grew by leaps and bounds. We went job hunting together. I spent more time at Irene's home than my aunt's. She told me a lot about herself. "My fiancé is in college and still has a couple of years to go before he finishes his teacher's training. That's why I need to find a job, to support myself and our daughter," she explained.

It was quite late when I bade goodnight on that first day and went to my aunt's house. My aunt's house girl had not left any dinner for me. If I hadn't eaten at Irene's house, I would have gone to bed on an empty stomach.

One day, Irene and I were going through a magazine. We saw an advertisement which read: **Lusaka, Zambia; Air hostesses wanted. Minimum education: Standard 6. Minimum height: 5 ft 6. Age: 20-25 years**.

Irene met all the requirements.

I had all but one, because my height was 5 feet 3 inches. To me, this job would have been a dream come true. Being an air hostess would have allowed me to travel all over the world, which was my heart's desire.

"I think you should apply. I have no doubt you will get the job," I told Irene.

"I would love to have such a glamorous job, but Zambia is such a faraway place and it would be hard for me to leave my fiancé and daughter behind."

We both decided to forget about that wonderful job opportunity and continue with our local job hunting.

One weekend, we visited Umtali Teacher's Training College and Irene introduced me to her fiancé. He was a tall, handsome young man. He was also very pleasant. I could now understand why Irene was reluctant to apply for the Zambian job. She didn't want to jeopardise her relationship with this fine young man by going to live in another country. As fate would have it, it happened anyway. A few months later, Irene had some sad news to share with me. "My dad has decided that we should all go to our rural home and live there for a while."

It seemed that the family had financial problems therefore it would be more economical for them to go and live in their rural home. My mind was in turmoil. I had grown to depend on Irene and her family. It would be impossible for me to stay on in that town after they were gone. My aunt's housekeeper had kept up her hostility towards me. I didn't want to go back home and burden my mother. So, I made a quick decision.

"Where is your home?" I asked Irene, prepared to go with her and her family.

"It's in Mozambique, just over the border."

I knew it wouldn't be wise for me to go to Mozambique because there was a war there. However, I decided to go anyway.

"When are you leaving?" I asked Irene.

"On Tuesday."

"I am coming with you," I declared. Honestly, I don't know what I was thinking, making such a poor decision.

Inexplicably, I thought of Mom's sister, Aunt Annie. It was a Thursday, at least four days before our departure to Mozambique, so I decided I'd use those days to visit her. I vaguely recalled where she lived because Mom and I had visited her some years back.

At about 4 p.m. that day, I disembarked the bus at a place called Duncan. The area was very mountainous. I had to descend a very high and rocky mountain. My aunt's home was right at the bottom. It had just rained, so I gingerly picked my way down the slippery slope.

A couple of hours later, I was still nowhere near my aunt's home. It was getting dark and I was beginning to panic. In no time, it got dark and I couldn't pick out the trail among the rocks and shrubbery.

As I stood there, wondering what to do, a deep voice from behind me called, "Who are you? Where are you going?"

I turned to see the form of a man advancing towards me. I was rooted to the spot, paralysed by fear. When the man finally stood before me, I noticed he had an axe perched on his shoulder, which made matters worse.

After some time, as I stood facing the man, quacking in my boots in terror, I realised that he was waiting for answers to his questions.

"My name is Pauline," I squeaked. "I am going to my aunt's house." I gave him my aunt's name.

"Oh, Annie is my cousin," the man said. When I told him that my mom was Annie's sister, he said, "Agnes is my cousin too. By the way, my name is Justin. I'll take you to your aunt."

I didn't exactly trust this man, but what choice did I have?

Slowly, we continued to descend the mountain with Justin leading the way. I was amazed that he could see the trail at all. It was pitch dark. I was relieved when we finally reached my aunt's home. Aunt Annie was overjoyed to see me, and she thanked Justin for accompanying me.

"It was so good of you to think of visiting me," my aunt said to me with excitement "I hope you will stay long."

"Actually, I am going back on Monday," I told her, and then explained, "On Tuesday I will be going to Mozambique with my friend and her family."

"Are you out of your mind?" Aunt Annie asked incredulously. "You know full well that there is a war raging in that country!"

I said nothing. Sensing my doubt, Aunt Annie pressed on, "You would be risking your life by going to Mozambique. You are welcome to stay here with me for as long as you want."

After considering it, I could see that Aunt Annie had a point. My earlier decision had been impulsive. I had no way of contacting Irene to tell her of my change of plans, so I just

stayed with Aunt Annie. I completely lost contact with Irene. Now, I would give anything to be in touch with her, although I know it's most unlikely. At least forty-three years have passed since I last saw her.

The kind of life my aunt led was tough. She was a strong and hardworking woman, and she expected the same from those around her. I began to wonder what I had let myself in for.

That first morning, Aunt Annie said, "Pauline, I know you are still tired from your journey, so I'll give you an easy task today. You are going to watch out for baboons in the maize field."

This mountainous area was home to hordes of baboons, so people had to guard their crops vigilantly. Their livelihood depended on it. I appreciated my aunt's considerateness. The task seemed easy enough.

I took one of my novels which I always carried around, then perched myself at a vantage point where I had a clear view of the whole field. In no time I was engrossed in my novel and the next thing I knew, Aunt Annie shot past me, shouting. I looked up to see a pack of baboons running out of the field, Aunt Annie in hot pursuit.

What I hadn't known was that baboons are sneaky. When they saw me sitting there, absorbed in my novel, they quietly entered the field from the other side and started eating the maize. It was a good thing my aunt thought to check otherwise they would have wiped out the whole crop, right under my nose.

The following day I got a tougher assignment. "You are going to the grinding mill today," Aunt Annie announced.

Instinctively, I knew I was going to be in for a rough day.

"Is it far?" I asked, very concerned.

"Oh, it's beyond those mountains," she answered, vaguely pointing to the horizon.

My cousin Mary, who was about twelve at the time, accompanied me to show me the way. My aunt measured a bucket of maize, which is about 20kg, into a sack. I carried the sack on my head, and Mary carried slightly less. We set out soon after breakfast.

We had to go up a steep mountain, then down the other side. Then up and down again a few more times. It was a gruelling walk, and the bucket of maize on my head was getting heavier by the minute.

We came to a swift flowing stream. *Where is the bridge?* I wondered.

Someone had felled a tall tree across the stream. That served as the bridge! To me it looked precarious to cross on that log, not to mention with the load on my head. But my cousin Mary thought nothing of it.

She hastily crossed to the other side. I had no choice but to gingerly cross the makeshift bridge. I barely made it to the other side. A couple of hours later, we arrived at the grinding mill, had our maize ground into mealie meal, and were back on our way home. I was as tired as a dog and I slept like a log that night.

Each year, the people in this area had to clear new land for cultivation. One could not plant crops on a previously cultivated patch. The landscape was steep and the rains always washed away the topsoil. One had to let a previously cultivated field lie fallow for several years.

That year we got down to the business of cutting trees to clear new land for our crops. Luckily, Aunt Annie's daughter-in-law came to live with us. Her name was Ida. She was a welcome addition, considering our workload. Better still, she and I got on very well and we took turns doing the more difficult tasks like going to the grinding mill.

All in all, my life with my aunt wasn't bad. Besides the tough work schedule, she treated me fairly well. About a year after my arrival at Aunt Annie's, everyone in the area was told to evacuate. The whole area was going to be turned into a timber plantation. Aunt Annie's husband bought property near a school called Costain. It was right on top of a mountain. The way we saw it, our being kicked out of our previous land turned out to be a blessing in disguise. The new place was ideal. The shops and grinding mills were both a couple of miles away. The bus stop was just a stone's throw away. Above all, Aunt Annie continued to treat me so kindly that I ended up staying with her for two years!

In the meantime, my parents didn't know where I was. I hadn't contacted them since I left home. I had nothing good to report, so I thought it best to remain silent. Later, I heard that Mom was sick with worry. When she finally heard that I was well and residing with her sister, she was relieved.

Straight away she sent my sister Maggie to fetch me. I went back home to Gokwe, but I felt somewhat restless. I wanted to get a job, although through experience I knew it would be difficult. But hope refused to die completely in me.

CHAPTER TEN

When Paul's girlfriend at the time invited me to Wankie, I jumped at the chance. She worked in the Southern Sun hotel. When I first arrived, I was impressed. I had never seen such beauty before. The hotel was picturesque, and its extensive grounds were well manicured. A large swimming pool was situated on the western side, and people lounged on the sides, sipping cocktails while gazing at the golden sunset. The place was heavenly. For two months, I stayed with my future sister-in-law e and all was well.

One day, a bus full of people pulled up in front of the hotel. Out of curiosity, I went over and engaged in conversation with one of the passengers. She was a wonderful girl and her name was Maggie. It turned out that her hometown was Rusapi, and that made us distant relatives according to custom.

"So where are you people going?" I asked Maggie.

"Why, we always come to this hotel for an outing!"

The hotel had a bird sanctuary, an arts and crafts shop, and a beautiful botanic garden. This attracted both local and international visitors.

"Where do you live?" I asked, because the hotel was secluded. There was no sign of habitation for miles around.

"I live in Main Camp. That's where I work as a nanny. You can come over and pay me a visit."

I didn't hesitate to accept her invitation and I visited her the very next day. Main Camp is the central headquarters of what is now known as Hwange National Park, which covers 1.4 million hectares, and contains 400 kilometres of game-

viewing roads. The offices and lodges, all neatly grass thatched, were eye-catching. The black employees, most of them game scouts, lived in a nearby compound which was fenced and gated to protect them and their families from wild animals. I could see some zebras, and a herd of impalas grazing nearby.

Maggie was happy to see me and she generously offered, "You can stay with me for as long as you want."

I decided to take her up on her offer because the place looked interesting to me. About a month after my arrival, Maggie shocked me by saying, "I have decided to quit my job and I am going back home."

"Why?" I asked in disbelief. To me Maggie seemed to have it all. She had a good job, a nice place to stay, and a fiancé. I had known about her fiancé soon after my arrival. He was a handsome young man called Allen. The two of them spent a lot of time together.

"The thing is," Maggie explained, "lately Allen has shown me a side of him I didn't know existed. He has been attacking me verbally for no apparent reason. Yesterday he actually threatened to beat me up."

"Maybe he didn't mean it," I said, trying to console her.

"Well, I am not sticking around to find out. You can have my job if you like."

I couldn't believe my ears. I'd been dreaming of getting a job in this area since I arrived. Finally, my prayers were answered. I was so excited that I could hardly contain myself.

The very next day I started working for Maggie's ex-employers. Their names were Mike and Prudence Kerr. They were such a warm couple and they treated me well. My job

was to take care of their two little girls. Although the little girls were difficult and sometimes gave me a hard time, their parents more than made up for it. I felt it was a blessing to be working for those people. Mrs. Kerr was born and raised in South Africa. She met and fell in love with Mr. Kerr when she and her family came to visit the national parks. Mr. Kerr was a game warden.

My bubble burst three months after I started working for the Kerrs.

"We no longer need your services," Mrs. Kerr told me one morning. "I am going back to South Africa and I am taking the kids with me."

I later learnt that she was divorcing her husband and was going to live with her parents in South Africa. This didn't come as a complete surprise. I knew the two were having marital problems.

By sheer chance, I got another job, doing housework for a guy named Mr. Monks. He was one of the kindest employers I've ever known. In the mornings, he would leave a list of things to be done before he went to work. He was a game ranger. I would go through the list in no time and be done for the day. The job was a piece of cake!

The only problem was the garden boy, Timothy. He didn't like me at all. He wanted my job. Although I did a good job of cleaning Mr. Monks' house, the minute I turned my back to go home, Timothy would slip into the house and make a mess so that it would look like I was not doing my job. I discovered this one day when I returned to retrieve something I had forgotten. From that day on, I made it a point to go back about twenty minutes before Mr. Monks

came back from work and clean up the place again.

For cooking, most people in the compound used paraffin stoves. The camp had no electricity. For economic reasons, some women went out in the bush to gather firewood. I later found myself joining them. It wasn't exactly safe to wander about in the bush. Being the centre of the whole national park, the place was home to all sorts of wild animals.

Once, we found ourselves in the middle of a herd of giraffes. We went ahead and gathered our firewood without incident. On another occasion, we saw a large herd of buffalo lying in the shade of a big tree just a small distance from the gate. We knew buffaloes were unpredictable and could be very vicious. We quickly backtracked into the camp.

Several years went by before Mr. Monks announced he was being transferred to another camp. It was a promotion to a higher post in a camp known as Mana Pools. Once again, I found myself without a job.

I went back to Kwekwe and was fortunately hired as a nurse aid at Chireya Mission Hospital. It was soon after independence and hospitals were re-opening, after they had closed during the liberation war. This hospital was a Catholic mission and my sister Maggie worked for the priests there. I had paid my sister a visit when the priests, desperately in need of staff to get the hospital going, offered me the job. I had just about given up hope of ever finding one, and to me it was a miracle that this job landed on my lap.

The job at the hospital turned out to be a whole new experience. To start with, the place was some 280 kilometres from the town of Kwekwe, right in the middle of nowhere. The only form of transport was a bus which plied the route

three times a week on Mondays, Wednesdays and Fridays. If it rained, the bus did not come at all because the creeks and streams would be overflowing and the bus could not cross.

Around the mission, it was mostly jungle, with clusters of huts dotted here and there in the distance. The whole area was mosquito-infested. In fact, I got a baptism of fire the very first month I arrived when I came down with malaria.

A terrible disease indeed! The symptoms are usually severe headache, nausea, hot and cold body spells, sometimes abdominal pains and dizziness. To make matters worse, the treatment, chloroquine or Norolon is awful. A person always feels worse before getting better after swallowing the bitter pills.

At first, the priests only managed to get just three of us, one nurse, myself and another nurse aide named Rebecca. So, at that point the hospital could not be opened. We only operated the outpatient clinic and the ante-natal ward. People would come from miles around, most of them with malaria symptoms. We treated some injuries and a few snake bites. A few babies were delivered.

One day, a girl of about fourteen limped into the clinic, accompanied by her parents.

"What happened?" our superior asked.

"My daughter has been bitten by a snake," the girl's father responded.

"What kind of snake?" the head nurse asked.

"It was a black mamba," the father answered, evidently shaken.

"Did you see the snake?"

"No. But by the description my daughter gave, I am

convinced that it was a black mamba."

"How long ago did this happen?" the nurse asked. The answers she got would determine the kind of treatment she was to administer. However, some of the answers were not helpful.

Since the people in this remote area did not have any watches at the time, the nurse did not get an accurate answer to her last question.

"It happened quite a while ago," the man supplied, showing some impatience. I could see that he was anxious for his daughter to be attended to, instead of the question-and-answer session. The nurse had to make a quick decision, whether to give the girl the only vial of anti-snakebite serum we had or not.

She decided not to give the girl the serum. Her reasoning was that if the girl had really been bitten by a black mamba, she wouldn't have limped in, but been carried in, since black mambas were known to be highly poisonous. She figured that the girl was probably bitten by one of the less poisonous snakes.

After the girl was attended to, she and her parents left. The following day, news came that the girl had passed away during the night. I felt awful. I remembered the girl's hopeful eyes as she sat there, waiting to be treated. I vividly remembered her pretty features, not to mention her hovering parents. I had nightmares for days due to this.

Rebecca, the other nurse aide advised, "Don't get too emotionally involved with the patients. Always do the best you can, but detach yourself."

Rebecca had worked in another hospital for several years,

so she had seen it all. What she said was easier said than done. I soon made friends with a newly married woman. Her name was Chekina.

By that time, the whole hospital had been reopened. Altogether, there were three nurses, two of whom were nuns, and six nurse aides. The hospital contained twelve beds in the men's ward, another twelve in the women's, and four in the maternity wing.

I first met Chekina when she brought in her five-month-old baby who had a fever. I liked her instantly. She was a cheerful person and she smiled a lot despite her difficult situation. From then on, our friendship grew. Each time she came to the mission, she would seek me out, and we would have a little chat.

Sometimes she would bring me gifts like eggs or fresh maize. I would return the favour by giving her some sugar or a piece of soap. The local people had no access to those basic goods at the time. There was no shop anywhere nearby. We had to go to Gokwe, which was more than 100 kilometres away, to buy our own supplies.

One day, Chekina came into the clinic with a raging fever. For once she wasn't smiling. At a glance, I could see that malaria had a good grip on her. After she was examined, the nurse decided to admit her into inpatient treatment. I fussed over her, making her as comfortable as I could. Soon after that, it was time for our dismissal.

My hope was that when I came back to work the following morning, my friend would be feeling better. That didn't happen. I went to see her, first thing that morning. Her eyes were open, but unseeing. Her teeth were clamped. Later

when it was time for her to take her medication, I tried to persuade her. "Chekina, Chekina, please open your mouth," I said desperately. I got no response. Then as I stood there, she closed her eyes and passed away, just like that.

At first, I was in total disbelief. *This is a nightmare, and I am going to wake up*, I thought to myself. When reality finally sank in, I was devastated.

I, as well as everybody else, knew that I was not cut out to be a nurse. I was too emotional. Breaking the news of her death to her husband was the hardest part. The poor guy went to pieces. Worse still, there was their poor little five-month-old baby to think about. It was a painful situation all round.

Four of us nurse aides used the hospital storerooms as our accommodation and the other two lived locally. We cooked our meals together over an open fire outside the building. One day, after dinner, we sat around the fire telling each other stories. The girls tried to outdo each other by telling terrifying stories about ghosts and witches.

"Girls, I don't believe in all that nonsense," I told them. "It's mere superstition."

I tried to switch to other topics, but my workmates wouldn't let it go. They continued driving their point home. "One day you will believe these things. Ghosts and witches exist."

Later we went into our separate rooms to sleep. My room was hot. One wall was stacked high with cardboard boxes of hospital supplies. At around midnight, when I couldn't stand the stifling heat any longer, I went outside for a breath of fresh air. I stepped down the porch, onto a path which led to

a stream and some villages beyond.

I didn't go far because I was afraid of the dark. I just stood on the path, a few feet from our quarters, enjoying the cool breeze. Suddenly, I felt the hairs on the back of my neck stand up. I looked down the path and saw someone running towards me at breakneck speed. The person was very tall, dressed completely in white. I froze on the spot.

As I watched, I noticed the person's feet didn't seem to be touching the ground. The whole incident felt like a dream. When the strange apparition was about thirty yards from where I was standing, it turned right and took another path which went behind the hospital.

That's when I snapped out of my trance, leapt onto the porch and shot into the house like a bullet, banging the door shut so hard the whole house shook. One of my housemates came out of her room and asked, "What wrong, Pauline?"

I couldn't answer her. I was still in shock. I told them about the phenomenon the following morning.

"I thought you didn't believe in the supernatural," one girl commented.

I had nothing to say to that. I didn't know what to believe anymore. To this day, I still can't figure out exactly what it was I saw.

One of the strange customs in this area was that women compulsorily didn't eat any meat. We tried to educate them that every person needs nutrients to live a healthy life, but they wouldn't let go of their tradition.

One day, a group of men were working together in a field when one of them discovered a dead chicken. "Don't throw it away," one of them said. "We should have it for lunch."

The others agreed. Chicken was a very scarce commodity, and most people only ate it once a year, at Christmas.

Only one man was doubtful. "I don't think it's a good idea to eat that chicken because we don't know what killed it. It could have been bitten by a poisonous snake, which means the chicken itself is now poisonous."

But the other men were determined to eat the chicken. "I have an idea," said one man. "We will feed some of it to that little puppy then wait. If the puppy doesn't die, that will mean the chicken is poison-free."

After the women had cooked the chicken, the men gave the puppy a big chunk, and then waited. Two hours later, the puppy was still playing around and showing no signs of distress, so the men sat down and made short work of the delicacy.

Thirty minutes later, the puppy dropped dead. There was panic as the men ran all the way to the clinic. They were sweating rivulets when they arrived and quickly explained to us what had happened. We attended to them, with their worried wives hovering in the background. Everyone was okay and we laughed about it later.

CHAPTER ELEVEN

Earlier on, Dad had retired from his job. He was now residing in Gokwe with Mom. Whenever I could get some time off, I would visit them. It was no surprise that our home had totally transformed. Dad was a good landscaper and on top of that, he planted various fruit trees around the home.

We had mango, guava, apple and orange trees and banana groves. He also cleared more land for crops and the harvest increased each year.

In 1985, Dad got sick. The illness lasted a long time and he was in and out of hospitals for many years. At first, it wasn't clear what he was suffering from. He was treated for many different things. At one point, he was diagnosed with tuberculosis. He stayed in hospital for two months. Although he was discharged, he still didn't feel well. My brothers decided to sell our rural home and buy Mom and Dad a house in town. There, my parents would have less work to do so they could concentrate on Dad's illness.

My brothers got together and opened a retail shop. The profits from this shop covered all my parents' needs, including the medical bills. It was agreed that I'd leave my job at the hospital to manage the shop. That request came at exactly the right time. I was growing resistant to malaria treatment. I was down with the disease at least once every month during the seven years I lived in that place. I felt that I was in danger of succumbing to the disease.

The move to town was a blessing. For the first few years the shop did well and my job was relatively easy. I ordered the

merchandise, paid the bills, paid the employees, and saw to the general running of the shop. We sold the daily newspapers, among other things, which gave me the advantage of being abreast of things.

Normally, the average person could not afford to buy a newspaper. I, for one, was totally oblivious of what was happening elsewhere. It surprised me to learn about the mayhem taking place in the countries around me. There was the turmoil in Liberia, the chaos in Somalia, the famine in Ethiopia, and the civil war in Angola. Worst of all was the genocide in Rwanda. I got a blow-by-blow of the horrific events as they unfolded.

I also followed the Middle East conflict. I remember at one point reading about President Clinton inviting one of the Middle East leaders to his holiday home in Mather's Vineyard for talks, to try to resolve the situation. I have to confess that I was more fascinated by that Island than the talks. I wished with all my heart that I could visit a place like that. Never in my wildest dreams did I think it could happen. As time went on, it became clear that I needed a vehicle to transport merchandise from the wholesale outlets to our shop. I had to get a driver's licence before I even thought of buying the car. After several driving lessons, I went for the road test and failed. I tried to rebook but I was told that I would have to wait for two months before I could take another test. That was too long for me to wait.

When I told my brothers about it, they came up with a bright idea. "If you go to Hwange, you could have your driving test right away. They never have any waiting lists there," one of my brothers told me.

"Where would I stay?" I asked with uncertainty.

My brothers suggested that I stay with a childhood friend of theirs, Dr Ngozo, who was working at the local hospital at the time. He had just got married and his wife worked at the same hospital.

I wasn't sure how I would be received since I was barging in on them uninvited. But I need not have worried. I had a hearty welcome. My stay turned out to be a memorable, luxurious holiday. Over the first weekend, Dr Ngozo and his wife took me to Victoria Falls.

We heard the thundering falls while we were still a distance away. I couldn't contain my excitement because I had never seen the falls before. When we finally arrived, I was totally speechless. It was breathtakingly beautiful. We walked into the rain forest caused by the large volume of water pounding the bottom. A path led us to the bottom of the falls where the water churned. We stood there for ages, just taking in the magnificent sight.

Nearby, stood the statue of the missionary David Livingstone. He was the first white man to see the falls and he named them after Queen Victoria. From there, we walked to the bridge where we saw some people bungee-jumping, plunging headfirst down some hundreds of feet. I am not an adrenaline junkie, so I didn't stay long to watch this craziness.

We crossed the bridge into neighbouring Zambia to view the falls from that angle. They were still breath-taking. Later, we returned to Hwange where Dr and Mrs. Ngozo continued to be charming hosts. In fact, these two were so hospitable that I prolonged my stay for as long as I could, but eventually I had to reluctantly bid them farewell and head

back home. I ended up not getting my licence because I failed the test again. I never got the opportunity to express my appreciation for their hospitality.

In 1990, my youngest brother, Chris, went to work in Namibia. The De Beers, a famous company from South Africa, opened some diamond mines in Namibia. The country had just gained its independence. The earlier government had deprived the black population, especially in the education department. There were not many qualified people among their lot at the time. Most qualified white people left the country and went to South Africa or elsewhere.

The De Beers Company sent its personnel to Zimbabwe to recruit artisans. My brother and some friends applied and got the jobs. I have to say it was adventurous of him to take that chance. Not many people knew much about Namibia at the time. The whole family was not overly enthusiastic about him going off to this unknown place. Nonetheless, my brother went ahead with his plans and left for Namibia that following month. He settled in a small town called Tsumeb. Soon after, his family joined him.

I decided to pay them a visit. I have always liked to travel and see new places. This was my big chance. My brother arranged with his wife's uncle who worked in Victoria Falls at the time to assist me to get a ride to Namibia. His name was Mr. Chipato.

It was complicated to travel to that country in those days. No buses went there from Zimbabwe. People had to rely on hitch hiking. I arrived in Victoria Falls at about four in the afternoon.

"I don't think there are any vehicles heading out towards Namibia at this time," Uncle Chipato told me. "We should try tomorrow morning."

I went with him to his home and spent a night there. He and his wife were so warm and welcoming that I almost postponed my journey, just to enjoy more time with them. The following morning, after a hearty breakfast, Uncle Chipato took me to the Caprivi Strip turn off. The road goes through Caprivi Strip, a narrow protrusion of Namibia stretching about 450 kilometres, between Botswana in the south, Angola and Zambia in the north, and the Okavango region in the west.

We stood in a bushy area, beside the dusty road. The deserted place was creepy, and I must admit I was nervous. Hour after hour passed and there was no sign of a vehicle coming our way. By late afternoon, Uncle Chipato concluded that there wouldn't be any vehicle coming that day, so back we went to his house.

I was becoming worried because it looked like my journey was going to fail and I would probably have to go back to Kwekwe. The following morning, Uncle Chipato surprised me by saying, "We will try another route today. It's longer, but it will get you there."

My spirits lifted. I was curious because I hadn't heard of an alternative route to Namibia besides the Caprivi Strip one. Uncle Chipato lived and worked at the Victoria Falls airport, a few miles from the town itself. We took a bus and arrived in town at seven in the morning. "Do you have your passport ready?" he asked.

"Yes, I have it right here," I wondered what I needed my

passport for at this point. I thought I would only need it when entering Namibia.

I followed him as we passed the thundering Victoria Falls and crossed the bridge to the Zambian border. We went through customs and immigration then emerged into Zambia. "This is as far as I am taking you," Uncle Chipato announced. "If you listen to my directions and instructions carefully, you will be fine."

I looked around me and saw a lot of activity going on. There were some black-market money changers, some people selling food and a line of vehicles waiting to transport people to Livingstone, Zambia's border town.

"When you get into one of those vehicles, it will take you to the main bus terminal in Livingstone," Uncle Chipato explained. "There, you should look out for a bus going to Sesheke Boma." He gave me the rest of the instructions and I memorised them. After that, we said our goodbyes and I was on my own. There were hordes of people from Zimbabwe going into Zambia so the vehicles filled up quickly.

In no time, I was at the bus terminal. I'd thought that the border post was a busy place, but I hadn't seen anything yet. The place was like a circus. I sat down on my luggage, waiting for my bus to arrive. Plenty of buses came and went but not one was going to my destination. It crossed my mind that maybe I could have missed the bus because of the pandemonium around me.

Just as I was losing hope, the bus finally arrived, the words 'Sesheke Boma' emblazoned on the front. I got in and took a window seat. The bus sped through rural Zambia, leaving a

cloud of dust in its wake. I noted that the rural homes we passed were the same grass-thatched mud-and-pole huts as those back in Zimbabwe. At about seven in the evening, the bus stopped. It was dark but I could make out a small building by the side of the road.

"You can go and buy food in the shop," the bus conductor said, pointing to the tiny building. "We are taking a break for the day and we will proceed with our journey tomorrow."

We trooped into the tiny shop, which was almost dark. Only a couple of candles illuminated the place. I bought a soda to wash down the food which Uncle Chipato's wife had packed for my journey. I would have loved something hot, like a cup of tea or coffee, but since the little shop didn't have any, I had to make do with the cold drink.

We slept outside on the ground. Usually, whenever a bus makes an overnight stop, passengers are welcome to sleep in the bus. But the driver and conductor of this bus didn't like the idea. The following morning my whole body felt numb. My thin blanket was wet with dew. At about eight o'clock, we all filed back into the bus.

After a short drive, the bus stopped again and once more we were told to get out. That's when I saw a very wide river in front of us, but there was no bridge. It was the Zambezi River. I wondered how we were going to cross. On the far bank, I noticed something that looked like a boat but thought nothing of it. After a while, the boat-like vehicle, which turned out to be a barge, started coming towards us.

About thirty minutes later, the barge arrived. Although it was big, I didn't think it was big enough to take all the people who were waiting to cross. I was amazed by what I saw that

day. First, the bus was driven into the barge, and we passengers were told to stand around it. Then two pickup trucks were driven onto the barge. Passengers from those vehicles stood around them. The barge then slowly made its way across the river.

I hadn't seen anything like that before. Zimbabwe is a country with many rivers, but most of the major ones have bridges. Once the barge reached the other side, everyone got out, vehicles and all. Uncle Chipato had instructed me earlier not to get back onto the bus once we crossed the Zambezi River. "The bus will take a right turn heading east, still in Zambia and you will turn left and head west towards Namibia."

I was left standing alone as everyone else got back into the vehicles. I started down the lonely road, going west. About fifteen minutes later, I saw a building which I assumed was the border post. The place looked deserted, and I wondered if I had come to the right place. I went inside and found two men sitting behind a huge stone desk. It turned out that one was the customs officer and the other was the immigration officer.

The immigration officer stamped my passport after asking me a hundred and one questions, some of which I found unnecessary. The customs officer went through my luggage item by item. At last, they let me go. I was puzzled by the fact that I didn't see any other travellers. Someone told me later that the rural people who lived in this remote part had no passports, and they didn't need them anyway. They just crossed into each other's country using their tiny row boats further down the river to avoid the border post.

Less than half a mile down the road, the Namibian border town, Katima Mulilo came into view. It was around midday, and I hoped to get some transport to Tsumeb, where my brother lived. I had no such luck. "The bus and several other vehicles always leave early in the morning," one guy informed me. *This journey is going to take me forever*, I thought to myself. I spent the rest of that day wandering through the small town. When night came, I slept on the veranda of a large shop, along with several other people.

At five o'clock the following morning a bus appeared, and the conductor was calling for passengers going to Grootfontein. I knew that was the town nearest to Tsumeb, so I got onto the bus. I saw other people running around, buying lots of food. I wasn't feeling hungry at the time, so I thought I would buy some along the way. The bus left Katima Mulilo at six that morning. It was a seventy-two seater and it was filled to capacity. I wondered where all the people had come from. There had been very few people at the station the previous night and Katima Mulilo was a small town.

The bus sped on for at least four hours nonstop. There were no rural homes by the roadside like in Zambia or Zimbabwe. All I could see was savannah shrubbery for as far as the eye could see, and sometimes animals roaming about. At about midmorning, I was beginning to feel hungry. I hoped that we would soon come by some shops or some vendors selling food by the roadside. When the bus abruptly stopped, I thought my hopes were realised and I could purchase something to eat. When I looked out, there was no shop or anything. It was all shrub for miles around.

"Recess!" the conductor called out. "Don't wander far from the bus because there are lions roaming about."

Most of us filed out. After about ten minutes, the bus resumed its journey. At about midday, I was very hungry. I watched everyone around me tucking into their food. *Why hadn't anyone told me that I had to buy food back in Katima Mulilo? If I had known that I couldn't buy any along the way, I would have done just that.* Again, the bus tore down the gravel road for a few more hours before stopping for another recess.

By four o'clock, my lips were dry and my stomach was rumbling. No one offered me some of their food. Finally, around six in the evening, we reached Rundu. We all got out and invaded some of the shops. I bought lots of food, ate some on the spot then took the rest back to the bus. I wasn't taking any more chances!

A few hours later, we reached Grootfontein. It was around eight in the evening. I and a group of other people huddled in the veranda of a gas station. The attendants there were kind and accommodating. We had access to their bathroom, which was spotless. I marvelled at their hospitality.

The following day, I got transportation to Tsumeb. Finally, after five days, I arrived at my brother's place. He and his wife were overjoyed to see me. I was given five-star treatment. It was well worth all the journey's hardships I had endured. Tsumeb was a very small town. There was nothing much to see or do. We spent most of our time watching movies or talking; me about home and them about their adventures when they first arrived.

CHAPTER TWELVE

The days sped by. I didn't want to go back home. All I wanted was to stay on and enjoy the life of luxury and laughter. But all good things come to an end. I had to go back to the shop, and my now elderly parents needed me. Reluctantly, I bade my brother and his wife farewell and travelled back home.

About that time, I noticed that our shop was going on a downhill trend. I couldn't pinpoint the root cause, but I tried my best to revive it. I even sold some assets and ploughed the money back into the shop but it didn't help. It reached a point where our expenditure exceeded our income. As the manager of the shop, I was in a tight spot, and it was a difficult time for me.

When my brother Chris and his wife invited me again to come to Namibia, I was delighted. I needed the break. Eagerly, I set out on my journey.

I used the same route as before. Things were a lot easier for me the second time because I knew what to expect and I was prepared. We had a good time, me and my brother's family. I planned to stay for a whole month, but a couple of weeks after my arrival, we received a phone call from my brother Paul. "Dad's condition has deteriorated," he informed us. "I thought you should know."

I immediately started preparations to leave the very next day. Chris decided to come with me. He hadn't seen Dad since he left home some three years back. We got transport to Katima Mulilo early that morning. "I hope that we will manage to get a connecting ride going through the Caprivi

Strip," Chris said. "It's shorter and we might even catch the evening train to Bulawayo."

I wasn't too keen on that idea. "I'd rather we use the Zambian route," I voiced. "I'm so used to it that I'd feel more comfortable."

"We will board the first vehicle going to Zimbabwe we get," Chris reasoned. "It doesn't matter which route it takes."

Just then, a pickup pulled up. "Anyone going to Victoria Falls?" the driver called out. My brother, myself and several other people piled into the back of the truck. No one asked which route he was taking. What mattered was getting to our destination. As the truck left Katima Mulilo, we realised we were taking the Caprivi Strip route. Finally, I was going to see the famous Caprivi Strip!

About a mile from Katima Mulilo, the truck stopped. We saw some angry-looking men, some with bows and arrows, some with spears and some with axes. They were all chanting and waving their weapons in a threatening way. We sat there, petrified. We were vulnerable and defenceless and the menacing looking men could kill us all in the blink of an eye!

The driver of the truck got out. Fortunately, he spoke the same language as the warrior-like men. After a brief exchange, the driver quickly got back into the truck and made a U-turn back to Katima Mulilo. He later explained to us that the men had some grievances with the Namibian government. By blocking that important route, they were trying to send a message.

"We will take the Zambian route," the driver announced. I was secretly pleased. Since I knew the route, I could point out a few things to my brother. However, things did not go

smoothly. We were delayed at the border post and by the time we reached the Zambezi River it was well past noon. To make matters worse, the barge was on the other side of the river.

Chris was getting very impatient. His leave from work was very short and he could not afford to waste precious time. He stood by the river's edge and waved his arms wildly, trying to attract the attention of the barge's crew. Nothing happened. Then after about an hour, the barge slowly made its way towards us. As soon as it touched our bank, we all got in, truck and all! We scrambled out on the other side and were soon on our way.

Chris and I were racing against time. "If we get to Livingstone by 4 o'clock we may be able to catch the evening train which leaves Victoria Falls at 6 o'clock," he said hopefully. But his hopes were dashed when, about five miles from Livingstone, the driver turned into a side road. A short while later we found ourselves in a small fishing village. "This is as far as I am going," the driver told us.

That came as a surprise. We all had the understanding that he was going to Livingstone.

It was already dark and there was no chance of us getting another ride. Chris was upset. Now we had another problem on our hands. We needed a place to sleep. We asked around the village for some rooms to rent for the night. We were told there was only one room available.

There were three of us, my brother, myself and a fellow male traveller. In the end, we had no choice but to share the room. When we went inside, we found that the room was filthy. There was only one small bed, and the bed sheets were

black-brown. I think they were once white but they were never washed.

Chris took the bed and I slept on the floor on one side while our travel companion took the other side. The worst part was that our travel mate played his radio all through the night. "My daughter bought it for me," he said proudly when we had tried to tactfully tell him to switch it off. I'm a light sleeper and the noise kept me up all night. Worse still, Chris got ill during the night. He moaned in pain and tossed and turned continuously. It was a long, miserable night. When morning finally came, we tried to find transport to Livingstone.

One local told us, "There is a bus which comes every day at noon. It brings people who buy our fish. But it does take other passengers."

That was a piece of good news for a change. We patiently waited for the bus. At about midday, it arrived. The passengers all got down and bought various quantities of fish.

An hour later, they all got back on the bus, my brother and I at their heels. We arrived in Livingstone at 2 o'clock in the afternoon. Chris was still not feeling well, so we took a cab to the border post. After we were cleared, we crossed the bridge into Zimbabwe, and made a beeline for the train station. We barely made it.

The rest of our journey was uneventful. When we finally arrived, Dad was really pleased to see Chris. He was up and about for a couple of days, then he relapsed. He was admitted into hospital.

Chris was due back in Namibia. I remember the day when the whole family was standing around Dad's hospital bed,

and Chris said his goodbye to him. Dad surprised everyone by saying, "Feed me before you go."

For several days, we all had been trying to coax him to eat without success. We all watched in amazement as Chris fed him to the last morsel. I think Dad was just trying to prolong his time with his youngest child. He passed away a couple of months later. That was in January 1994.

During that period, the shop wasn't doing very well. I can't put my finger on exactly what went wrong, but among other things, we'd had a series of burglaries.

The first time, the thieves got in through the roof. They removed some tiles then lowered themselves into the shop through the hole. On that occasion, not only did we lose the goods they stole, but we ran into the expense of having the roof repaired. The second time, the burglars broke in through the back door, and that time they almost cleaned out the shop. The third time the thieves were so daring, they broke the key on the front door! They got away with considerable merchandise.

The fourth time, the notorious thieves broke into our neighbour's shop, then drilled a hole in the wall into our shop. That day they stole the day's takings along with other items. It was all such a drain to the shop. To make matters worse, the Zimbabwean economy was going downhill daily. It reached a point where the shop was no longer viable and we had no choice but to close it. It hit me hard. There I was, without a job, and still reeling from the loss of my dad. It was a depressing time for me.

My spirits lifted when a close friend of mine who was related to Chrispen's wife, invited me to go on holiday with

her. Her timing was perfect because I was down in the doldrums then. "We are going to Lake Kariba and I will cover all the expenses," she told me. "All you have to do is come along."

I was elated. I had never been to Lake Kariba before and I was excited to visit it. My friend brought her brother, his wife and an uncle of hers who was to be the designated driver. The five of us left Harare early that morning and set out on the 365-kilometre trip. On the way, we stopped at Chinhoyi Caves. I had heard a lot about the mysterious caves and was thrilled to see them for myself.

The history of the caves is that they were used by the local people to hide from Ndebele raiders. A guide showed us around the place. First, we descended a hill and at the bottom there was a pool of cobalt blue water. It was an impressive sight. We sat there absorbing the beauty of the place.

A long time ago people believed that the pool was bottomless, and if anyone dived in, they would never resurface. However, that theory was proved wrong. A couple of tourist divers, complete in their diving gear, jumped in as we looked on. They resurfaced after a while. The guide then took us back up the hill to an opening which led into the caves. As we entered, there was another cave to our left.

"That's the dark cave," the guide explained to us, then warned, "It's off limits. No one should try to go in there."

We curiously peered into the forbidden chamber but could not see a thing. It was pitch dark. We followed the guide as he led us along the artificially lit cave. The walls were dripping with water and it made the inside of the cave cool

despite the scorching heat outside.

When we reached the end of the cave, we got a surprise. There in front of us was the cobalt blue pool! The same pool we had approached from the other side. It was awesome.

From Chinhoyi Caves, we continued with our trip to Lake Kariba. When we were some distance away, I looked up and saw a giant blue wall.

"What's that?" I asked, thinking that maybe my eyes were playing tricks on me.

"That's the lake," my friend answered. I was somewhat puzzled because it looked vertical to me. How can a lake be vertical, I wondered. As we drew nearer, it began to look more horizontal.

Lake Kariba is the world's largest man-made lake and reservoir. It is over 220 kilometres long and 40 kilometres wide. There are several islands in the lake including Maaze, Mashape, Forthgrill, Spurwing and Snake Island. Lake Kariba is situated along the Zimbabwe-Zambia border.

On our first morning we went fishing. Although we three ladies weren't excited about it, we went along to humour the guys. A motorboat took us to one of the Islands in the middle of the lake. I had a moment of panic as the boat sliced through the water at high speed. I imagined that if we accidentally capsized, I would drown in a minute since I could not swim. We reached the island safely and the guys got down to the business of fishing.

My friend and I explored the island a bit but could not go far because we were cautioned that there were wild animals about. Luckily for us, the fish were not biting so the men got fed up and we returned to the mainland. That afternoon we

visited the crocodile farm. It was scary watching the big reptiles with their long jaws at such close range. One of the crocodile keepers provided a free show for the spectators.

He goaded one particularly large crocodile with a long stick. The crocodile would lunge at him, its jaws wide open. The man would jump out of the way and the crocodile would miss him by a fraction of an inch. Most of the people in the crowd seemed to enjoy the show, but not me. I thought that the man was foolish, dicing with life like that.

Later, we went for a sunset boat ride. The view was breathtaking and the sunset was stunning. After dinner, my friend's uncle treated us to stories about the time he spent in college in Russia. He told us how much he missed our traditional meal of *sadza*, and how badly he missed family and friends while he was there. I wished I had an opportunity to go to a faraway country. For me, missing family and friends would have been a small price to pay.

We returned to Harare after three days. When I got back home, grief hit me like a ton of bricks. I was back to the reality that Dad was gone. Time hadn't eased the pain at all. The only good thing was that Chris and his wife invited me and my sister Maggie to visit them again in Namibia. "I got a transfer and we now live in Windhoek," he told us over the phone. "You will love this city."

Windhoek is the capital city of Namibia, so I had no doubt in my mind that I would love it. It was a far cry from the small, quiet town of Tsumeb. I was very excited. Chris, with the help of a friend, drove all the way from Windhoek to Victoria Falls to get us. His friend, who was a Namibian and had never visited Zimbabwe before, was impressed by

the Victoria Falls.

"I am going to bring my family here someday. They just have to see this wonderful place!" he told us. On the way back, Chris drove from Victoria Falls to Katima Mulilo, and from there his friend took the wheel.

As pleasant conversation flowed in the car, Chris brought up the subject of the amazing Victoria Falls. His friend, not to be outdone, said, "We also have some falls here in Namibia. I can take you to see them if you like."

We told him we would be delighted to see them. He turned the car off the main road and took a narrow strip.

A little while later we came to a wide river, but we couldn't see any falls.

"Come," Chrispen's Namibian friend called excitedly. "Here are the falls!" He pointed to a part of the river.

All we could see were rapids caused by the fast-flowing water over some rocks. No falls to speak of. But we didn't have the heart to speak our minds. The poor guy was trying hard to impress us.

"These are nice falls," Chris said to his friend. Maggie and I readily agreed.

The trip to Namibia was wonderful. Windhoek was such a lovely city. There was so much to see and so much to do. We even indulged in some shopping sprees. My sister and I thought it was the height of our holiday. But my brother and his wife were not done yet. They announced that they were taking us to Swakopmund, a beach town some hundreds of miles away.

That was my very first time seeing the ocean in person. There were miles and miles of beach, and we had a dip in the

cool sea. I thought things couldn't get any better, but they did! From Swakopmund, Chris took us to Walvis Bay. For the first time in my life, I saw a real ship. In fact, there were several of them. After we got tired of gaping at the sea-faring vessels, we left for home.

Just as we were leaving, someone told us to take a turn at a certain point, about halfway between Walvis Bay and Swakopmund. "You'll find the highest sand dune in the whole area. You wouldn't want to miss seeing that!" he stressed. When we arrived at the dune, we all agreed that the guy hadn't exaggerated. The sand dune was miles high and some people were waving from the top.

Chris, his wife, and Maggie wasted no time. They started to climb, and after considerable time they were at the top, waving down at me. I followed, but soon discovered that it was no easy task. The sand was burning hot. When I put on my shoes, the sand filled them up and it was impossible to go on. I almost gave up, but seeing the others up there, seemingly having the time of their life, gave me the determination.

When I finally reached the top, it was well worth the effort. What I saw up there seemed unreal. To our left, the Namib Desert stretched forever. To our right was the Atlantic Ocean. We stayed on the sand dune for a while, taking in the amazing scene. The most fun part was the descension. One could choose either to slide straight down or run zigzagging down the dune. If you ran straight down, you would inevitably fall flat on your face because of its steepness.

From there, we dipped ourselves in the ocean once more, to cool ourselves after the desert heat then set out back to

Windhoek. Two weeks later, my sister and I returned to Zimbabwe.

After returning from my third and last trip to Namibia, I was back to square one. No job, nothing to do to pass time, no social life to speak of, nothing whatsoever to occupy me physically or mentally. In 1996, when I could no longer take any more of that listless existence, I decided to take the bull by the horns and go to Harare to look for a job. My mom was sceptical. "Many young school leavers are pounding the pavements looking for jobs to no avail. What makes you think any employer would employ you at fifty?"

I knew my mother was right, but I thought it was worth giving it a try. By sheer chance and a stroke of luck, I did get a job. A Welfare Organization called Khaitri Welfare Society had advertised in the daily paper for an honest hard working nurse aide. They interviewed me, and with the help of the reference letter I got from the priests at Chireya Mission Hospital, I was hired.

I worked for this society for four years. My job was to take care of a 96-year-old lady, Mrs. Adams. I worked the night shift. During this time, I was living with my daughter Annie and her family. Although I was very comfortable, after two years I felt the urge to be independent and live by myself. My daughter was not happy about it, but I was adamant. I went to a suburb known as Sunningdale and rented a room. I immediately realised that I had made a big mistake. The rent took half of my salary and the other half went to food and transport to and from work.

On top of that, the landlord was a mentally unbalanced person. The man raved all day long, sometimes into the

night, banging doors and even breaking things for no apparent reason. It took very little to set him off. Everyone walked on eggshells around him. There was a tense atmosphere in the house. One by one, the other tenants left to find lodgings elsewhere, but I hung on for a little longer.

In the end I had to leave too because living with that crazy man was a real nightmare. I found another room to rent in the same neighbourhood. But it seemed that I had jumped from the frying pan into the fire. My new landlady appeared to be sweet and nice at first. Things started to go wrong when, one day, she borrowed a hundred dollars from me and promised to square up with me at the end of the month.

I didn't have any hundred dollars to spare. I was living from hand to mouth as it were. I told her so and suddenly she turned nasty towards me but was nice to the other tenants who had obviously lent her the money. It was such a trying time for me, having to deal with her hostility. The next time she came to 'borrow' money from me I had to give her. That meant I had to cut down on other expenses. On several days I had to walk to work, not less than 10 kilometres.

As for food, I practically lived on tea and bread because I could not afford to buy meat. It was during this time that a close friend of mine, Irene Mapuranga paid me a visit. She was a schoolteacher. "I have three days of my holiday left so I thought it would be great if I spent them with you!" she gushed. Just the sight of my dwellings will put her off, I thought to myself.

I didn't have the comfort of a bed, a stove, a fridge, a couch or even a stool to sit on. I used a small tin paraffin stove for my cooking and I had a thin mattress to sleep on.

During the day, the mattress served as a couch. To my surprise, my friend didn't bat an eyelid at my deplorable quarters. "Let us thank God for this precious time we have with each other," she told me.

Sure enough, we had a wonderful time together despite the poor diet. What touched me most was that although Irene's other friends, most of whom were well off, extended invitations for her to visit their homes, she declined and stayed with me for the three days she had promised.

After Irene left, I remained cheerful and a little more optimistic about life in general. The bubble burst when my landlady came to borrow money from me again. She hadn't paid back any of the money she borrowed from the tenants and she never did. I was stressed to the limit because I could not make ends meet because of her selfish behaviour. After a year of that miserable life, I finally swallowed my pride and went back to live with my daughter and her family. A great weight was lifted from my shoulders and I felt tremendous relief. Everything went well until, towards the end of my fourth year, Mrs. Adams got seriously ill.

She could no longer stand or walk by herself. It became extremely difficult for me to get her out of bed to go to the bathroom for her bath. I needed another nurse aide to help me. I explained my problem to my employers and they instantly brought in another nurse. That was not the end of my problems.

Although this new girl was young and beautiful, working with her was difficult. The first morning she arrived, she found me struggling trying to lift Mrs. Adams from the bed onto the wheelchair. Instead of helping me, she just sat there

and watched me as if she was watching a movie.

"Can you please come and help me?" I pleaded.

"I am sorry, I can't. I am not here to do your job for you." she said sarcastically. "My shift will start the minute you are out of that door."

I was dumbfounded. It was unbelievable that anyone could be so callous. I was left with no choice but to go next door and ask a young man named Natsai to help me. He came with me, and together we lifted Mrs. Adams from her bed, soiled clothes and all, and carried her to the bathtub. I felt awful for the poor young guy, but he was such a gentleman about the whole thing.

I didn't want to run to my employers and tell stories. Although this girl had such an unlikable character, I wasn't going to throw her under the bus. Instead, I quit my job and returned to Kwekwe.

This was in 2000. Back in Kwekwe, things were worse for me than before. At age fifty- four, I knew I could never find another job. At first, my eldest daughter helped by teaching me the art of candy making. I loved it because it helped to pass the time. When the kids from a nearby school swarmed my house to buy the sweets, that was a bonus.

However, other people from my neighbourhood started to make the candy. Soon the market was flooded and I had to stop. Back to square one. My biggest problem was boredom. Life became bleak, with nothing to look forward to. I couldn't accept that this was all there was to my life. I prayed for some miracle to happen.

Sometimes when I got too downcast, I'd visit my sister Maggie at the convent where she lived with other nuns. They

soothed away my worries with their wise and comforting words. My spirits lifted and I felt better for a couple of days or so, then it started all over again.

CHAPTER THIRTEEN

In 2004, my prayers were finally answered. My daughter Annie and her husband Cleopas communicated with Elizabeth, a very close family friend, and a distant relative who had been living in the USA for quite some time. When they told her that I wished to go there, she told them I was welcome to stay with her. I couldn't believe my luck.

Sitting on the plane that day, I felt a tremendous weight lift off my shoulders. Our plane went via the Netherlands and we had a stopover at Schipol Airport. Five hours later, I was on the last leg of my journey. We arrived at JFK airport at about six in the evening. I looked around me with intrigue. Everything I saw was fascinating. The sheer volume of people milling around was astounding.

When we emerged from the airport terminal, I was shocked by the blistering cold. I looked around me at the expanse of white wonderland. It was a beautiful picture. That was my first time seeing snow in person. However, I was not dressed appropriately for the kind of weather and the cold penetrated right to my bones. We quickly got into the car and were soon on our way.

As we sped down the three-lane throughway, I wondered why I did not see any traffic going the other way. When I looked further to my left, that's when I saw the other three lanes going towards the city. Amazing! Soon after, we came to a bridge. My jaw dropped at the sight of the colossal structure. I had never seen anything like it before. "It's called the Tippan Zee," I was informed.

The length of the bridge is over 4.8 kilometres. There are seven lanes of traffic, three going each way and one switchable. We raced along, my eyes glued to the window. What amazed me most was the network of roads, crisscrossing all over the place in all directions like a cobweb. How anyone could find their way in that maze was a mystery to me.

We arrived in Kingston around dinner time. People were already eating when I walked in. The table was crowded with all kinds of foods. I dived in and ate to my heart's content. After dinner, I saw everyone helping themselves to various kinds of desserts. Some heaped ice cream onto their bowls, others cut slices of cheesecake and some took tea with cookies.

"Did I walk in on a celebration?" I finally had to ask.

"What celebration?" someone responded. "This is the standard dinner. Wait 'til you see a celebration!"

I didn't have long to wait. A guy who went to college with Elizabeth invited us to his wedding in Ithaca. Normally, it's a three and half hour drive, but we got lost and it ended up taking us five hours to get there. The address we had took us to Cornell University. We drove around the compass, trying to locate our destination. The University alone is bigger than my hometown, Kwekwe. I was impressed.

When we finally found the wedding venue, the reception was already underway. It was a well-planned wedding, and I thoroughly enjoyed the event, not to mention the food. There was more than plenty for everyone. A pastor who had flown all the way from Great Britain gave a speech. The man was a comedian, so we all had a good laugh.

All in all we had a good time. On our way back to Kingston the following evening, we had a little adventure. We had decided to take a short cut through the back roads. In our excitement, we forgot to fill the gas tank. Just a few miles out of Ithaca, the gas gauge was on empty. At first, we weren't worried. We assumed that sooner or later, we were bound to come across a gas station. But as we ate the miles, there was no sign of one in any of the little towns we passed.

Finally, almost in despair, we spotted a single gas station by the roadside, in front of a shop. The shop was unlit, so we reasoned no one was in there. We pulled up by the pump and Elizabeth got out of the car. When she tried to pump the gas, nothing came out. The thing was either empty or broken. We were worried as we dejectedly drove away. I imagined the car sputtering to a stop, and us huddling together for the night, in that confined space, on that dark lonely road. It would have been a dangerous situation.

Elizabeth drove slowly, praying for some miracle to happen. Her prayer was answered when we came to a small town, bustling even at that time of night, where we filled our gas tank. From there we proceeded home without further incident.

My stay with Elizabeth was good. Although I missed my family terribly, it was offset by the kind way she treated me. I felt as if I was home away from home. The best part was, like me, Elizabeth liked to travel. For me that was the icing on the cake.

That year, the snow fell in tons. One morning, we woke up to some eight inches of snow. Although it was beautiful to look at, it was inconvenient. The kids couldn't go to school,

and most people could not drive to work.

We got down to work, shovelling the snow to clear the driveway. It was great fun. The snow was light and powdery. The kids were having a good time, building a gigantic snowman. They were so creative about it. I watched as they shaped the head, used some dry seeds for the mouth and two buttons for eyes, and finally stuck a carrot to serve as a nose.

From what I could see, food was attainable to everyone. It would be impossible for anyone to die of starvation. I noted that there were food banks where food was freely distributed to those in need. There are also soup kitchens, where hot meals are served to anyone, no questions asked.

The two things which are very expensive in the US are accommodation and medication. That explains the issue of homelessness, which I was surprised to note. You have to hold a job which pays at least the minimum salary to afford to rent a modest place to live. But for one to get a job, one has to supply an address. Which means once a person becomes homeless, the chances of them getting a job are almost non-existent. It's a vicious cycle.

As for medical issues, one has to have what they call insurance. That's the equivalent of medical aid in Zimbabwe. I learnt all this the hard way. One day when I got ill, I went to see a doctor. The consultation fee was so steep that I almost backed out. That's not all. After the doctor examined me, he referred me for some tests, which were equally expensive.

Having patients go for a series of tests before the doctors prescribe any treatment is the standard procedure. I was finally told that I needed surgery, which cost me a packet. It

was quite an experience, and I prayed that I would never, ever get ill again. The education is free up to high school. There is no uniform requirement, except for private schools. Students wear whatever they like. The dress code is somewhat lax.

One other thing I noted with great surprise in America is the return policy. If you purchase some goods, then later decide you don't want them after all, you can return them and get your money back without any questions asked. The salespeople are always pleasant to customers, but even nicer when one is returning something.

At first I was afraid of returning my purchases. But my friend Deby asked me to go with her. I watched from afar as she returned some items, expecting her to have a hard time with the salesperson. Instead, she was treated like royalty. Incredible! Some people even make a hobby of it. They go on shopping sprees, and then later return the merchandise. Deby calls it 'shopping and unshopping'.

I met Deby soon after my arrival in the US. We met at a toddler play centre. She brought her young son Elias, while I brought Elizabeth's son Ano. I was immediately drawn to Deby because of her sincere smile and warm personality. From then on, our friendship grew in leaps and bounds. Whenever I had a problem, she was the person I called and she always did her best to help me. She was a true friend.

One of the things I loved doing was gardening. We had just moved into a new house, so I got down to the business of clearing the small piece of land behind the house. I pictured the place ablaze with blooming plants in a couple of months or so. Then one day I had a bad case of itching on my arms, legs and neck. At first I thought it was a passing thing.

But when the itching persisted, I called Deby. As usual, she had an explanation for it. "You came into contact with poison ivy," she told me over the phone.

"What is poison ivy?" I asked, bewildered. I had never heard of the plant.

Deby came over right away. When she arrived, she showed me a tiny three-leafed plant. "This is poison ivy. Always watch out for it and avoid any contact with it," she instructed. She then gave me some remedy to ease the itching.

As the months went by, life continued to be exciting for me. I was reasonably happy. Elizabeth has three children. Her first born is Kudzai. The young man is a true gentleman. He is so polite and well-mannered. He is very intelligent and is studying law at Boston College. The second born is Kuda. She is soft spoken, agreeable and very considerate. The third and last born is Ano. When I first arrived, he was only fifteen months old. He and I quickly bonded, and I feel as if he is my own grandson. Ano is extremely kind. He is always concerned about other people's well-being. He is never aggressive, and he is talented in playing some musical instruments. It's been a pleasure to be part of their lives.

One day, a friend of mine called Sarah and I were invited by some friends of hers to a boat ride on the Hudson River. Sarah's friends, Norman and Caroline, owned a beautiful luxury boat. The boat sailed up the river with Norman at the helm while Caroline, Sarah and I admired the breathtaking scenery on the banks of the river. The sky was cloudless and a cool breeze fanned our faces. I enjoyed these rare idle moments.

We sailed upstream and I was surprised when we came upon an island right in the middle of the river. There were several campers who seemed to be having a good time. Some were cooking over an open fire and some were playing loud music. I would have loved to walk around the tiny island but I am not one for camping. Roughing up has never been my thing. I prefer the luxury of a hotel with all its trimmings. Norman steered the boat around the island and back home. It was an unforgettable day.

That summer, we went to Cape Cod for a vacation. We checked into a small hotel in Yarmouth, after which we made a beeline for the beach. However, it was cold and cloudy and the beach was empty. Not a single soul in sight. We walked up and down the beach, taking pictures. We felt as if we were on a deserted island.

Eventually we had to go back to the hotel because it was getting chilly. The hotel gave us information on some places of interest in the area. We took in a captivating sea lion show. The following day, it was clear and sunny. We chose to go to Martha's Vineyard. We took a ferry from Falmouth, and in less than an hour, the island came into view. We were not disappointed at all.

The quaint little shops which looked as if they had just been painted, were a pretty sight to behold. Nevertheless, someone from the mainland had warned us not to even think of going into those shops. We were told that the prices there were steep. We, instead, opted for a bus tour around the island. The bus driver doubled as the tour guide. "That house once belonged to Diana Ross," he told us as we drove down a narrow road. "That's the road to President Clinton's

vacation home."

We all craned our necks, but the house was nowhere in sight. We passed a town called West Tisbury and, after a while, came to a place known as Gay Head Cliffs. There, we had a thirty-minute break. Half the passengers went up to view the lighthouse which was perched on a hill, and the other half went to see the rugged Gay Head Cliffs, which slopped down to the beautiful beach below.

From there, we continued with our tour, until we came to Edgar town which, the driver told us, is considered the island's capital. We proceeded northwards. "That's the beach where the movie *Jaws* was filmed," the driver pointed out as we passed the jam-packed beach. I was especially fascinated because I had seen the movie *Jaws*.

We completed our tour of the island in about three hours. We then browsed the picturesque shops, just to kill time before we returned to the mainland. We spent our third day at the beach in Yarmouth. It was a hot day and the beach was crowded. I sort of liked that.

I dipped myself into the ocean for a while then spent the rest of the day soaking in the sun and watching people. It was quite interesting. On our last day in Cape Cod, we did a little bit of shopping before we hit the road. All in all, it was a good vacation.

In November of the same year, Elizabeth was invited to Savanna, Georgia, by one of her college pals. It was a thanksgiving celebration as well as a reunion for Elizabeth and her friends. Generously, Elizabeth let me tag along. I knew I was going to be like a fish out of water among those college graduates, but that didn't stop me. I was determined

to see as much of the United States as I could.

We left Kingston at six in the evening, Elizabeth's husband Innocent at the wheel, travelled all night, and arrived in Savanna at eleven the following morning. That was seventeen hours of travelling non-stop, except for refuelling. We had a great time in Savanna and it was well worth the long trip. Tina, the lady hosting the gathering, gave us a tour of the town. I took in some stately homes, which had wealthy owners. We also saw some old houses, which looked very beautiful. The town certainly was rich in history.

"What are those people doing?" I asked, pointing at a large crowd of people, some wielding cameras as they moved up and down what seemed to be a clearing of some sort, beside a beautiful church.

"Oh, that is an old cemetery," Tina supplied. "It's a tourist attraction."

I was surprised to hear that. I had never heard of a cemetery being a tourist attraction before, but looking closer, I could see why this one was.

Some of the unique headstones were eye-catching. The domes and statues at the heads of some graves were quite something. We completed our brief sight-seeing of the town and went back to Tina's house where the party was still in full swing. I have never seen people dance so hard. I thoroughly enjoyed watching these people trying to out-dance each other.

The following day, when we were preparing to leave, Tina suggested that we go via Atlanta and visit the aquarium. "It's one of the biggest in the country," she told us. We were tempted, and did consider visiting this aquarium, but we

were all feeling tired, so we decided to go back the way we came.

On our way back, we made two stops, the first one in Virginia, overnight, and the other in Washington DC. We took in some sights, like the Capitol, the Washington Monument, the White House and a few other places of interest. My biggest wish was to go up the Monument. It is a 555 foot marble tower which is situated within the national mall. It was built to commemorate the first US president. Unfortunately, when we arrived, there was a very long line of people.

It was late in the afternoon when we left Washington DC on our last leg of the journey home. We arrived in Kingston in the middle of a snowstorm. It was hard to imagine that when we left Savanna, it had been blazing hot, with clear skies. This whole trip was long and tiresome but quite memorable. I wouldn't mind doing it again.

In the spring of 2008, I had my first visit to New York City. I and three friends, Sarah, Caroline and Diosa made this trip just for sight-seeing. Caroline had a brother who worked in the city. His name was Larry, and this guy knew the place well. Our hired bus dropped us at Bryant Park and immediately Larry whisked us into the subway. The underground network of railway lines was so confusing to me that I couldn't tell which train was going where.

After a short ride, we got off the train and emerged near the Empire State Building. This is New York's tallest skyscraper. It is a hundred and eight stories high and has a viewing deck on the eighty-fifth floor where one can see almost the entire city. As we excitedly looked around us and

snapped some photos, it started to rain. Not a downpour, but a steady, cold drizzle. We were so disappointed that our day was ruined.

"Cheer up," Larry soothed us. "I have a brilliant idea. I will take you to the museum. It's all warm and cosy in there, and you will enjoy the art."

I'd never been in a museum before, and I didn't think I would be interested in any form of art. But I was wrong.

The paintings were captivating. For hours, we walked from one partition to another, admiring paintings from all over the world. When we were tired of walking, we took a break and treated ourselves to lunch in the museum's cafeteria.

After lunch, we still had an hour to kill before catching our bus. "Let's go see the Egyptian mummies," Caroline and Diosa suggested. The two girls, being Americans, seemed to be fascinated by African exhibitions. But Sarah and I are Zimbabweans and we were more curious about American art. It was a case of 'The grass is greener on the other side.' After a short debate, Sarah and I won. We went to see the American works.

Although I loved everything I saw, from the paintings of the early settlers in their ox driven wagons, to those of the Wild West, one particular painting captured my heart. It was a painting of Lake George. As I gazed at it, I felt the tranquillity of the place. When Caroline noticed how taken I was by this masterpiece, she said, "You know, Lake George is not far away from Kingston."

I could not believe my ears! Sure enough, later that night when I told Elizabeth about the serene Lake George, she said,

"Oh—that's less than a couple of hours drive from here. We will go there on Saturday if you like." Things were getting better and better!

We set out for Lake George early that Saturday and arrived at about 9 a.m. Immediately, I could see that it was exactly as I had seen it in the painting at the museum. The artist hadn't exaggerated at all.

I sat down on one of the benches overlooking the lake. Time melted away as I let this beautiful place soothe my soul. I saw some groups of tourists going to view a historic fort nearby. Others got into ferries which sailed up and down the length of the lake. I didn't care about any of that. I just wanted to absorb and enjoy the peaceful scene before me, with the majestic mountains in the backdrop. The place is a tourist paradise for sure.

When my friend Deby discovered that I loved reading, she and her mom kept a steady stream of books coming my way. Most of them were truly inspiring. The books I like to read are biographies, history and religious books like Heroes of Faith. They sent me Joni, by Joni Earickson; Annie Frank - Remembered; The Hiding Place; Endurance; Return From Tomorrow; Polished Arrows; and Ninety Minutes In Heaven, just to mention a few. These books inspired and entertained me.

On entertainment, there is never any shortage of it in the US. New York City, which is only ninety miles south of Kingston, has lots of things going on all the time; Broadway shows, concerts, and various sporting events like baseball, basketball and football.

I am not an outgoing person. I am content to sit in front of my TV and watch my favourite shows. One of them is America's Funniest Home Videos. That show is hilarious! I always get lots and lots of laughter from it. I like a few other reality shows.

One show I particularly like has a travel element in it. During this show, the participants travel to various destinations. Getting to see these places, such as New Zealand, Switzerland, Thailand, keeps my dream of travelling alive. Who knows, one day I might be able to go to one of those beautiful places.

The other TV program I watch without fail is by Joel Osteen. This guy is truly gifted. He uplifts my spirit each time I listen to his messages and I feel greatly inspired. It was after one of his messages that I decided to write this book. For years I had always entertained the thought but was not confident that I could do it. Even when I had started writing the book, more than once, I almost gave up, but listening to Joel Osteen gave me the courage to go on.

In December 2012 we went to New York City to watch a Christmas show. John, a guy from our local church, organised the trip, from booking the tickets for the show to hiring the bus for our transportation. He told me that we would have at least five hours to spare before and after the show.

I gathered that people would pair up and some would make small groups as they explored the city or did their shopping. I didn't know anyone and I didn't fancy roaming the streets of New York alone, so I asked John and his wife Janice if I could join them. They agreed and it turned out to

be one of the most fun days of my life. They were extremely accommodating and kind.

The show itself was spectacular. I had never seen anything like it before. After the show, we went for lunch at a restaurant known as Forrest Gump, named after the movie. From there, we went to Rockefeller Centre to see the Christmas tree. A large crowd was milling around so we wiggled our way around it and took pictures as we went.

The tree was a pretty sight, all sixty feet of it with thousands of lights and ornaments. The star on top of the tree is said to weigh a whopping five hundred pounds and is nine feet wide! I was having great fun, and before we knew it, it was time to go to the bus and back to Kingston.

In 2010, my sister paid me a visit from Zimbabwe and we visited New York City. Innocent, Elizabeth's husband, lived and worked in the city, so he knew his way around well. He kindly offered to be our guide for the day. We started by walking from the bus terminal, past Wall Street, where we saw people mobbing the bull statue. After a brief stop for some pictures with the bull, we proceeded to Battery Park, where we boarded a ferry to Liberty Island.

We saw the Statue of Liberty when we were still a distance away. It was an awesome sight. The statue towered from the ground and everyone in the ferry couldn't take their eyes off it. It was mesmerising. When the ferry docked, we all got out. The statue was even bigger at close range. The Island itself was surprisingly small but well kept, with a lush green lawn and inviting shady trees.

We slowly walked around, viewing the statue from all angles. We had the opportunity to enter it, and climb the

stairs to the crown, but we chose to forgo that. We needed the time to take some Manhattan sights. We only stopped for lunch, and boy, wasn't I glad we did! I had fish and chips, British style! It had been a very long time since I'd had those, and it reminded me of my younger days.

On our way back, the ferry stopped at Ellis Island. Both Islands are rich in the history of the early immigrants. Some people disembarked to look around but we simply didn't have the time. As soon as we disembarked at the city port, we went into the subway which took us to Central Park and Columbus Circle. From there, we went to St Patrick Cathedral. That was my second time visiting the huge church, but one can never get tired of this unique holy structure.

Later, we walked the short distance from the cathedral to Rockefeller Centre. We went straight up to the viewing deck on the roof. It's called "the top of the rock". The view there is superb. We could see for miles around the city. It was getting dark and we had to go and catch our bus back to Kingston.

Kingston is a small historic town. It was once the capital of the state of New York. The mighty Hudson River runs past the edge of the town. There are enchanting parks by the river, where families can have picnics and enjoy the scenic views across the river. There is also a beautiful beach where people can dip themselves during the scorching summer days.

The only thing that surprised me about the place is that the animals live among people. There's lots of deer roaming about all over the place, and they wreak havoc in gardens. There are other animals too, like squirrels, groundhogs, and even bears, which are a menace. In fact, I encountered a bear

one morning. It was a terrifying experience. The bear was standing behind some bushes a few yards ahead of me.

Luckily, a kind motorist took the trouble to stop and warn me. "There is a bear behind those bushes," she told me. "I wouldn't go any further if I were you!"

At first, I couldn't make any sense of it. But then, the huge black bear emerged from behind the bushes. I almost dropped with fright. Fortunately, I saw a neighbour of mine and I ran and dived into his car. He didn't ask me any questions because he saw the bear too. He kindly drove me to my destination. It was a close shave.

A couple of years after my arrival in the US, I made some very good friends, who live in a community a few miles from Kingston. It was Elizabeth who introduced me to them. The first time she took me to visit the community, I was highly impressed. The place itself is so beautiful, nestled below a mountain, with breath-taking scenery.

The place looks extremely beautiful, even in winter. On that first day, the moment we entered the community, everyone we met greeted us warmly, introduced themselves, and welcomed us.

The community consists of about three hundred members, mostly self-reliant families. They plant most of their food and raise their own stock for meat. They have a factory which is their source of income. On that day, we had a communal meal outdoors. Tables and chairs were arranged in long rows. Young men in white served the food, which was incredibly delicious.

"Tell us about Zimbabwe," one of the members said to me. Everyone seemed interested to know.

I told them about the beauty of the country and added, "You would love it if you visited. The people there are generally friendly." It was one of the most enjoyable evenings I have ever had. When I went back home, I wrote to these good people expressing my appreciation for everything, hoping they would invite me again, which they kindly did.

The more I learnt about them and their community life, the more impressed I was. They live a Christian life and refuse to be distracted by worldly things. For instance, they don't watch TV. For entertainment, they play all sorts of games. One day I participated in some of the games, and I was amazed at how the time flew. There was a lot of laughter as we played the games., and I thoroughly enjoyed myself.

Another interesting aspect of this community is that most of the female members have excellent culinary skills as well as other talents. The kids are always well behaved and so adorable that I always feel like hugging them all.

One of my closest friends in the community, Rosemarie, taught me to appreciate nature. She and I would take walks, and she would point out plants, rocks and wildflowers, something I never took time to do before. Sometimes we would sit by a birdseed container and she would point out the birds as they came and went. "That's a mockingbird," she would inform me. "And that's a hummingbird," or "That's a woodpecker."

I am very thankful to have acquired the awareness of nature. Earlier in my life, I wouldn't give any bird or wild plant a second glance. Another thing I loved about my community friends was their singing. It always uplifted my spirit. When it came to the children's singing, their angelic

voices and cherubic faces never failed to melt my heart.

I had a pleasant surprise one day when a couple of my other community friends, Gillian and Gerry, took me for a walk at a place known as The Walkway. This is a bridge across the Hudson River solely built for walking and vehicles are prohibited. The bridge is two kilometres long. Most people go there for the scenery and others go for exercise. Some go to walk their pets. When my friends and I arrived at the walkway, it was crowded, on an extremely hot day.

As we walked across the bridge, my friends surprised me by greeting almost every person we met. They would say, "Good afternoon, what a nice day." Sometimes they would say, "Hello, what a beautiful dog you have." Most people responded warmly, a few were curt or unresponsive, but my friends were undeterred. They kept it up. "Those babies are so cute, are they twins?" they asked a young couple resting under a tree shade at the end of the bridge.

"Yes, they are," the young couple answered proudly. They seemed pleased that their babies were being admired. All in all, not only did I thoroughly enjoy my walk, but I also learnt a lesson in humility. Good manners cost nothing, but can put a smile on someone's face. Another remarkable thing about this community is that they are always alert about what is happening around the world, and always lending a helping hand where it's needed.

During hurricane Katrina, they sent their members to Louisiana to help. They also sent some of their men to Pakistan after the landslide disaster.

The men spent weeks in the remote mountain villages, building temporary shelter for people who had lost

everything. Some members of the group went to Haiti after the earthquake.

A few years back, Gillian and Gerry, with their two sons, joined forces with another organisation and visited Zimbabwe on a charity mission. Whilst here, they worked with AIDS patients and AIDS orphans. The community has other branches all over the world in places like Australia, Britain and even in Paraguay. I am truly blessed to have known these people.

One day, Deby took me to a hotel up in the mountains called the Mohonk Mountain House, where she was once employed. Tom, Deby's husband, drove us up the narrow, steep, winding road. My first sight of the enchanting castle blew my mind. It is situated in the heart of a scenic natural area, which stretches out for hundreds of acres around the majestic hotel. Sheer rocky cliffs rise above a crystal blue glacier lake.

The first thing we did when we arrived was feed fish in the lake. There is a vending machine which takes a dime for a handful of fish food. After that, we went up the trail to the very top of the mountain. As we climbed, the surrounding view, including the hotel itself, became more and more spectacular. By the time we reached the top, we were winded. We still had the tower to climb, but when we finally got to the top, it was well worth it. We could see far, and I felt as if I was on top of the world. Next, we took on canoe paddling in the lake. Although it was a hot day, the breeze on the lake was cool.

After the invigorating exercise, we leisurely explored the hotel's botanic gardens. The exotic flowers were in full bloom

and we were treated to a blaze of colours. Our next stop was the nursery where we saw plants from all over the world including Africa! We ended the day by having a late lunch of waffle fries. It was an enjoyable day.

One day in September, the year I arrived in the US, Elizabeth announced that we were going apple picking. I had no idea what she was talking about, but I soon found out. We drove a few miles out of Kingston and arrived at a large apple farm. At the gate, we bought an empty bag which we would fill with apples. "Go up the field, take the first left turn, and you can pick the apples to your right," one farm employee directed us. When we reached the part of the field he had indicated, it was full of people already picking apples. People are allowed to eat as many apples as they want before filling their bags. We really went for it. We took at least a couple of hours sampling various kinds of apples; the Gala, the golden delicious, the Fuji, and other types. Apple trees don't grow too tall so it's relatively easy to pick them.

It was such a pleasant day as we mingled with other families in the apple field. When we had had enough, we filled our bag and went back home.

I remembered that in the sixties, Zimbabwe had something similar. Once, I and some of my family visited Mazowe citrus farm. We were let loose into the field and we ate oranges like crazy, but we were not allowed to take away any, unless we purchased them.

The same happened when we visited Hippo Valley. We were allowed into the sugar cane field and were told that we could eat any amount of sugar cane we wanted, but could not take any home. We did our best but the problem with sugar

cane is that it is hard to peel and to chew. No one was able to eat more than one cane. Unfortunately, things have changed since then.

At one point, my friend Sarah had five jobs! However, there came a time when she could no longer juggle the jobs so she kindly offered me one of them. She could have just let the job go but she considerately let me have it. I was very grateful because I needed it.

The job was to clean two large buildings which were used as offices. The larger of the two buildings was used by Doctor Andrea, a psychiatrist. The building is three stories high, counting the basement. Altogether there are eight rooms and three bathrooms. It took me roughly three hours to clean the place from top to bottom. Since it was my first time doing this kind of job, I made several blunders which could have cost me the job if the doctor were not tolerant. On my very first day on the job, I accidentally locked myself out.

I was halfway through my cleaning when I decided to take out the trash, not knowing it was the kind of door that locks itself when you close it. I stood there, stunned. My handbag with the keys and my cell phone were visible through the glass door. There was nothing I could do but to go home.

When the doctor came later that day expecting the place to be spick and span, she was met with disarray. While her patients waited, she put the place in order. A while later, I arrived at the office to retrieve my handbag. I stammered an apology to the doctor, fully expecting her to fire me on the spot for my error. But she brushed it aside and said, "Don't worry about it. I am sorry that you got locked out." I couldn't believe my ears!

During the following weeks, I had another problem. Since the whole building was carpeted, it needed to be vacuumed, but the type of vacuum cleaner they had was strange to me. I was familiar with the two-wheel, upright type. This one had two components: the upright two-wheel part and a trailing oblong three-wheel part. I just could not figure out how the thing worked. I didn't want to admit to the doctor that I was unable to use the gadget for fear of losing my job.

So, I took the broom and brushed the carpet thoroughly. It was such hard work and it took far too long. One day the doctor arrived while I was in the middle of the gruelling job of brushing the carpet. I was sweating rivulets. "Is everything alright?" the doctor asked, surprised at what she was seeing.

I knew there was no way out for me but to come out clean. "I am sorry doctor, but I just can't figure out how to use that vacuum cleaner," I confessed.

"I can show you how it works if you like," the doctor responded. She immediately showed me, step by step, how to use the monster vacuum cleaner. After that, things were much easier for me and the carpet was much cleaner.

I always did my cleaning on Sundays when no one was about. One day when I was cleaning the upstairs rooms, I heard a loud banging at the door. I ran downstairs and found two people, a man and a woman, standing there. I opened the door, which I kept locked for fear of intruders, to find out what they wanted, and to my surprise they brushed past me and entered the office. "We have an appointment with the doctor," the man told me.

Both the man and woman were acting strangely, pacing the room with their arms folded to their chests, their faces

sullen. Suddenly, I felt uneasy. Various thoughts entered my mind. They could have been thieves and the building was full of valuable gadgets lying around. If they stole any of those, the blame would fall on me and I could go to jail. Another thought was that they could be violent. They could kill me and get away with it. Hate crimes are a common occurrence in the US. I realised I shouldn't have opened the door for them.

I called the doctor, but she didn't answer the phone. I tried to continue my cleaning but I was so nervous that I didn't accomplish much.

After about forty minutes, the pair finally left without saying a word to me. At about the same time, the doctor returned my call. I explained to her what had happened and she was surprised, "I didn't have any appointment with anybody today so I don't know why those people were there."

I began to apologise for my blunder. Once more the doctor brushed aside my apologies. "You didn't do anything wrong," she told me. "I am sorry that you had to go through that." I was astonished by the doctor's level of tolerance and absolute tact.

My last beach holiday in the US was in Ocean City Maryland. That was the best holiday resort I had ever seen. The hotels are just a stone's throw from the ocean. I guess that's how the place got its name. You step out of the hotel right onto the beach. The beach itself is one endless stretch. The hotels are spectacular. The place is glamorous. We stayed on the second floor of a unique twenty-one story luxurious hotel. It was an ideal holiday.

In April of 2013, I returned home to Zimbabwe. It was a

happy reunion with my family. Sadly, soon after my return, my mother passed away.

I now live a quiet life in Bulawayo.

All in all, I am thankful for the life I have led up to this moment. I feel truly blessed.

AFTERWORD

I will end with my favourite topic: travelling! In the US, my wish is to visit Hawaii, Alaska and California. I would also like to visit The Netherlands, the United Kingdom of Great Britain and Switzerland. I know that's a tall order, but there is no harm in dreaming is there?

Last but not least, Zimbabwe has plenty of beautiful places I still have to see. Places like Great Zimbabwe. Although this wonderful historical place is near my hometown of Kwekwe, the opportunity never arose for me to visit. Inyanga and Vumba Mountains, Bridal Veil Falls and Birchenough Bridge are also on my list.

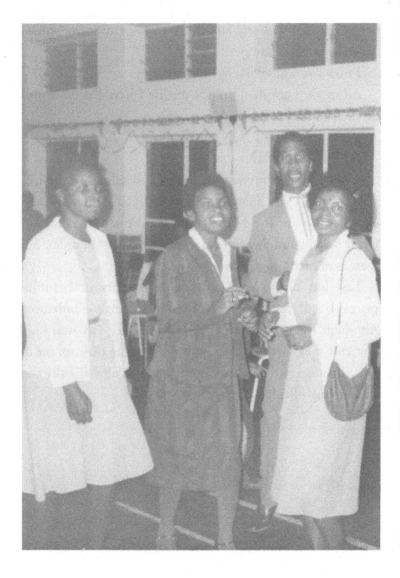

My daughters, Ennie and Rose and myself

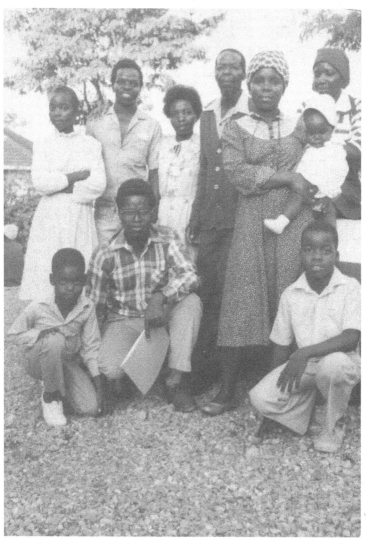

Kneeling - my nephew Llyod, my brother Paul and nephew Lovemore.

Standing - my daughter Ennie, my brother Chris, myself, my father, sister-in-law, baby Precious and my sister Maggie.

Debbi's husband Tom, myself, my friend Debbie, Tino, Kuda, Ano and Elizabeth at Mohawk Hotel in Kingston, New York (2006)

Colleague Rebecca, myself and colleague Mrs Zinyama at Chireya Mission Hospital (1982)

Me and my friends at Bruderhof Community (2007)

Me shovelling snow, Kingston New York (2006)

Me at Mabrose shop, Kwekwe (1992)

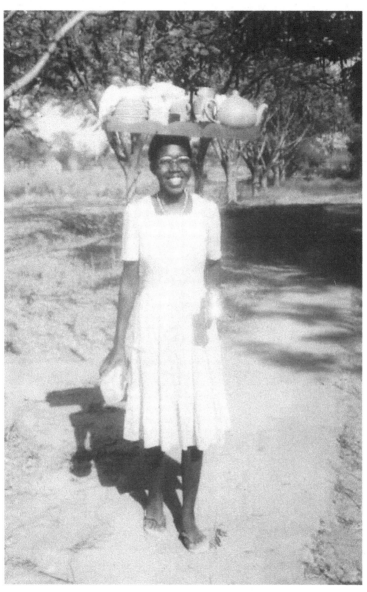

My sister Maggie with the priests' dinner (1982)

Sitting - my mother and my brother Mike.
Standing - my father, my brother Paul, and my brother
Aleck (1968)

Glossary

Sadza – traditional meal made by boiling a mixture of mealie meal (cornmeal) and water to form a thick pulp

Mealie Meal – cornmeal; corn/maize ground into a fine powder

Muriwo – collard greens

Mowa – pigweed, *Amaranthus Thunbergil*

Maheu – a low alcoholic drink (<3%) made of a mix of sugar, sadza, water and sometimes yeast and other grains. Also known as African sweet beer

Musone / Mufushwa– sun-dried collard greens

Mbuva – packed lunch

Mutakura – a Zimbabwean meal usually comprising at least two of the following boiled ingredients: dried maize, ground nuts, round nuts.

Cities – Some cities referenced in the story were renamed following Zimbabwe's independence from Rhodesian colonial rule as follows:

- **Que Que – Kwekwe**; second largest city in the Midlands province of Zimbabwe; author's hometown
- **Inyanga – Nyanga**; city in the Manicaland Province of Zimbabwe; hometown of author's mother
- **Umtali – Mutare**; largest city in the Manicaland Province of Zimbabwe
- **Gwelo – Gweru**; largest city in the Midlands Province of Zimbabwe
- **Rusapi – Rusape**; town in the Manicaland Province of Zimbabwe; Makoni District; hometown of author's father

- **Salisbury – Harare**; the capital city of Zimbabwe and part of the Harare Metropolitan Province
- **Hartley – Chegutu**; town in the Mashonaland West Province of Zimbabwe
- **Sinoia – Chinhoyi**; city in the Mashonaland West Province of Zimbabwe; home to the Chinhoyi Caves
- **Wankie – Hwange**; town in the Matabeleland North Province of Zimbabwe; home to Hwange National Park, the largest natural game reserve in the country

Milton Keynes UK
Ingram Content Group UK Ltd.
UKHW042236300823
427788UK00001B/9

9 781914 287367